DAVID BUSCH'S

dSLR MOVIE SHOOTING

COMPACT FIELD GUIDE

David D. Busch | Rob Sheppard

Course Technology PTR
A part of Cengage Learning

COURSE TECHNOLOGY
CENGAGE Learning·

Australia, Brazil, Japan, Korea, Mexico, Singapore, Spain, United Kingdom, United States

COURSE TECHNOLOGY
CENGAGE Learning

David Busch's dSLR Movie Shooting Compact Field Guide

David D. Busch, Rob Sheppard

Publisher and General Manager, Course Technology PTR:
Stacy L. Hiquet

Associate Director of Marketing:
Sarah Panella

Manager of Editorial Services:
Heather Talbot

Senior Marketing Manager:
Mark Hughes

Executive Editor:
Kevin Harreld

Project Editor:
Jenny Davidson

Series Technical Editor:
Michael D. Sullivan

Interior Layout Tech:
Bill Hartman

Cover Designer:
Mike Tanamachi

Indexer:
Katherine Stimson

Proofreader:
Sara Gullion

Library of Congress Control Number: 2012930793

ISBN-13: 978-1-133-60068-8

ISBN-10: 1-133-60068-9

Cengage Learning is a leading provider of customized learning solutions with office locations around the globe, including Singapore, the United Kingdom, Australia, Mexico, Brazil, and Japan. Locate your local office at: **international.cengage.com/region**.

Cengage Learning products are represented in Canada by Nelson Education, Ltd.

For your lifelong learning solutions, visit **courseptr.com**.

Visit our corporate Web site at **cengage.com**.

Printed in the United States of America
1 2 3 4 5 6 7 14 13 12

Contents

Introduction

Throw away your cheat-sheets and command cards! Do you wish you had the most essential information you need to shoot top-quality videos using your digital SLR's advanced movie-shooting features? We've condensed the basic reference material you need in this handy, lay-flat book, *David Busch's dSLR Movie Shooting Compact Field Guide*. In it, you'll find the explanations of *why* to use each movie-making setting and option, and how to capture the kind of video that can stand alone—or which you can edit into a polished production. That's the kind of information that is missing from the cheat-sheets and the book packaged with the camera. Everything in this book is written to help you out in the field, as a quick reference you can refer to as you master the full range of things your digital SLR can do in the video realm.

About the Authors

With more than a million books in print, **David D. Busch** is the world's #1 selling digital camera guide author, and the originator of popular digital photography series like *David Busch's Pro Secrets, David Busch's Quick Snap Guides,* and *David Busch's Guides to Digital SLR Photography*. As a roving photojournalist for more than 20 years, he illustrated his books, magazine articles, and newspaper reports with award-winning images. Busch operated his own commercial studio, suffocated in formal dress while shooting weddings-for-hire, and shot sports for a daily newspaper and upstate New York college. His photos and articles have appeared in *Popular Photography & Imaging, Rangefinder, The Professional Photographer*, and hundreds of other publications. He's also reviewed dozens of digital cameras for CNet and *Computer Shopper*, and his advice has been featured on NPR's *All Tech Considered*. Visit his website at www.dslrguides.com/blog.

Rob Sheppard is a photographer and videographer who says his favorite location is the one he is in at any time. He is the author/photographer of hundreds of articles about photography, and more than 35 books. Sheppard is a well-known speaker and workshop leader, and a Fellow with the North American Nature Photography Association. He was the long-time editor of the prestigious *Outdoor Photographer* magazine and helped start *PCPhoto* (*Digital Photo*). Presently he is editor-at-large for *Outdoor Photographer*.

His website is at www.robsheppardphoto.com;
his blog is at www.natureandphotography.com.

Chapter 1

Quick Setup Guide

Shooting video has similarities to shooting still photos, but there are also important differences. While this entire book is designed to help you get the best in video from your dSLR, this chapter contains essential information you need to get started shooting video quickly. You'll learn how to choose and use some basic video controls and features here. (See Figure 1.1.)

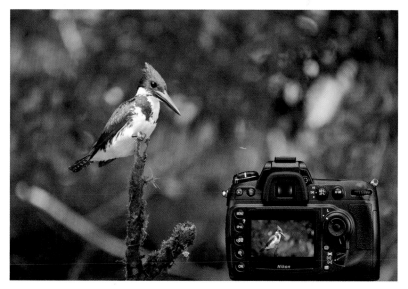

Figure 1.1 Video is now an important part of digital SLRs and offers the photographer new ways of capturing images, including movement and sound.

Batteries

Batteries are obviously important for any digital camera. You simply cannot shoot without a charged battery installed in the camera. But for video, this becomes even more important. When you shoot video, your sensor is powered continuously as you prepare for the shot and while you actually record video. This means that your LCD also has to be on and powered. Both the sensor and LCD need a lot of power. In addition, you are recording a great deal of data to the memory card, way beyond what you would record with a still photo, even a RAW photo, and that processing and recording to the card also uses up power.

A good rule of thumb is this, have at least three batteries. (See Figure 1.2.) This allows:

- One battery in your camera.
- One back-up battery in your bag.
- One battery being charged if needed.

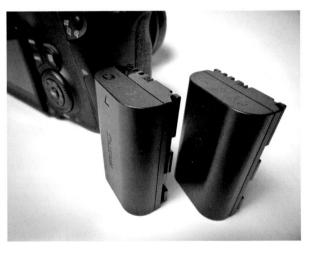

Figure 1.2

Batteries are critical to your success when shooting video.

Choosing Video Resolution

Your camera very likely comes with several choices for resolution and frame rate. (See Figure 1.3.) Video is very different from still photography in that resolution is fixed based on several standards. In addition, video uses a resolution that is far smaller than anything that is available on a dSLR so the actual megapixels of the camera have no impact on the resolution of video, which

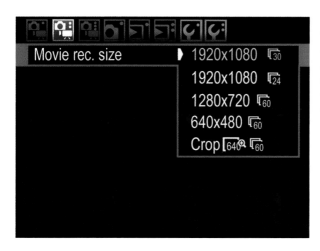

Figure 1.3
You will find video resolution and frame rate settings in a camera settings menu.

may be 1920 × 1080 or 1280 × 720 pixels in the two most common high definition modes.

The default resolution that comes with your camera is probably a good choice to start with. However, you may hear about the use of other resolutions, whether or not your camera has them, and you may be confused as to what is best. One thing to keep in mind about video is that this is not about shooting a single image. Video is shot with many frames per second, typically 30 frames per second. That means that for each second of video, your camera is taking 30 individual pictures at whatever resolution you are using for video.

There are three key resolutions for video, and these are standards for playback on televisions so these are the only choices:

1. **HD Video 720.** This is a high definition video standard that has dimensions of 1280 × 720 pixels. This is approximately equivalent to a one-megapixel still photo. Because this is the smallest high definition video resolution, this allows cameras to more efficiently shoot those multiple images per second for video and this produces smaller video files. This resolution is also often used for shooting at high frame rates that require the camera to deal with an added burden of more images per second. This is a standard for HD video.

2. **HD Video 1080.** This is a high definition video standard that has dimensions of 1920 × 1080 pixels. This is approximately equivalent to a two-megapixel still photo. This offers more resolution than 720, but it also means that the camera needs more processing power to deal with it. More and more cameras are using this as the standard way of shooting HD video as camera manufacturers become more sophisticated in developing

internal processing to handle it. You will not see a huge difference between 1080 and 720 resolutions on a standard HD television set. However, 1080 video does allow some cropping of the final image for display that 720 does not.

3. **SD Video.** Standard definition video was the traditional video before high definition video. It has a fraction of the resolution of high-definition video; plus other aspects of this standard do not offer the image quality of HD video. SD video has a resolution of 720 × 480 pixels in the U.S. and other countries that use what is called the NTSC standard. Other countries use slightly different standards, such as PAL, that may include a slight increase in resolution.

Video resolution settings are usually found in a camera settings menu. NTSC and PAL are SD video standards, not HD video, though you may see HD video referred to in this way. HD video resolution is either 720 or 1080 and there is no other resolution for HD television display anywhere in the world.

Choosing Frame Rate

Frame rate refers to how many frames or fields per second are captured while you are recording video. The common standard for video in the United States is 30 frames per second (fps), although the European standard is 25 frames per second. Because of this difference, people sometimes refer to the US standard as NTSC high-definition video and the European standard as PAL high-definition video, but this is incorrect as those standards only refer to standard definition video.

You will typically find up to three different frame rates for shooting video. (For simplicity, I'm going to refer to the shooting rates as *frames per second* or *fps* from now on.) Some cameras will only have one option, whereas other cameras will offer all three:

1. **30 fps.** This has long been a standard for video. Technically, broadcast video is at 29.97 fps, and many cameras will give precisely that. For the average photographer shooting video, that technicality is not going to make much of a difference. A rate of 30 frames per second is exactly that, 30 individual frames shot per second of video. This is what can really stress a camera and especially a memory card because both have to continually deal with this amount of data flowing through the camera and onto the card for however long you are shooting video. 30 frames per second gives you an appearance that definitely looks like video that you would see on television.

2. **24 fps.** Theatrical movies are shot both with film and video typically at 24 frames per second. This has long been a standard for the film that was used for movies. This has a slightly different look than 30 fps, and many people feel this tends to give video more of the look of a movie. Where you will see this is in the way that motion is recorded. Higher frame rates record motion more smoothly, but it is that less smooth recording of movement of movies that some people like and so choose 24 fps.

3. **60 fps.** The higher frames per second of 60 fps gives an even smoother movement to video, but it comes at a cost. Remember that this means 60 individual little pictures are being shot and recorded per second which is a lot of data to go through the camera and record to the memory card. Because of this, 60 fps is often only available at 720 HD resolution. Some people like to shoot 60 fps and then use it at 30 fps when they edit the video. This creates a bit of a slow-motion effect because it shows everything at half speed.

Frame rate settings are usually found in a camera settings menu.

Progressive Scan vs. Interlaced Scan

As you probably know, video images as you see them on your TV or monitor consist of a series of lines that are displayed, or *scanned*, at a fixed rate. When captured by your dSLR, the images are also grabbed, using what is called a *rolling shutter,* which simply means that the image is grabbed one line at a time at the same fixed rate that will be used during playback. (There is a more expensive and uncommon option called a *global shutter* that captures all the lines at one time.)

Line-by-line scanning during capture and playback can be done in one of two ways. With *interlaced scanning*, odd-numbered lines (lines 1, 3, 5, 7… and so forth) are captured with one pass, and then the even-numbered lines (2, 4, 6, 8…and so forth) are grabbed. With the 60 fps interlaced format, roughly 60 pairs of odd/even line scans, or 60 *fields*, are captured each second. (The actual number is 59.94 fields per second.) Interlaced scanning was developed for and works best with analog display systems such as older television sets. It was originally created as a way to reduce the amount of bandwidth required to transmit television pictures over the air. Modern LCD, LED, and plasma-based HDTV displays must de-interlace a 1080i image to display it.

Newer displays work better with a second method called *progressive scanning.* Instead of two interlaced fields, the entire image is scanned as consecutive lines (lines 1, 2, 3, 4…and so forth). This happens at a rate of about 60 frames per second (not fields). (All these numbers apply to the NTSC television system used in the United States, Canada, Japan, and some other countries; other

places use systems like PAL, where the nominal scanning rates are 50 frames per second.)

One problem with interlaced scanning appears when capturing video of moving subjects. Half of the image (one set of interlaced lines) will change to keep up with the movement of the subject while the other interlaced half retains the "old" image as it waits to be refreshed. Flicker or *interline twitter* results. That makes your progressive scan options of 60p or 24p a better choice for action photography. The choice between progressive scan and interlaced scan may be settled for you: your dSLR may not offer both, nor a variety of frame rates.

Choosing a Memory Card Best for Video

When you look at the amount of data that has to be recorded to a memory card for video, such as 30 two-megapixel images per second, it is easy to understand that you are going to need big and fast memory cards. How big a card and how fast is dependent on the resolution and frame rate of the video being shot, as well as the way the manufacturer has set up the camera to compress the video.

A note on video compression format: Your camera will use a specific compression format to record video to your memory card. dSLRs only record compressed video to save space on the memory card. The most common compression formats used today are QuickTime H.264 (.mov) and AVCHD (.mts), though there are others. You have little to no choice in the compression format or the particular amount of compression that your camera is using, though this file compression will affect how easy your video files will be to view on your computer.

You definitely need a fast enough memory card to handle the video being processed and sent to it from the camera. For example, Canon says that you need a minimum capability of handling 8 megabytes per second (MB/s) or a 55X card, but to ensure you have enough speed, you won't go wrong looking for a card that will handle at least 15MB/s or 133X. Two things can happen if you don't have a fast enough memory card:

1. The camera will "drop frames," meaning that you will lose frames of video. That can look bad on playback.

2. The camera will quit recording video because it can't get video from camera to memory card fast enough. That will be very frustrating if you are shooting something important.

Today's memory cards are rated by how many megabytes per second (MB/s) of data can be transferred on and off the card, so checking this speed is fairly easy. Look for that minimum of 15MB/s. While you can often use a

Class 6 SDHC card or non-UDMA 133X CompactFlash card, you will have consistently better results with a Class 10 SDHC card or UDMA high-speed CompactFlash card. The key is to look for something above 15MB/s for speed. (See Figure 1.4.)

Video can use up a memory card's capacity in a hurry. Typical video from a dSLR can mean that 20 minutes of video will fill an 8GB memory card. You will probably be frustrated with anything smaller than an 8GB memory card when you are shooting video.

Figure 1.4

Select a memory card that fits your camera with a listed speed of at least 15MB/s.

The Shutter Speed Challenge

Since video is offered on most dSLRs and there are a whole range of shutter speeds available, you might think that you can use any shutter speed you want just as you might when shooting a still photo. That thought could get you into trouble and give you video results that are less than satisfactory.

Shutter speed for video is limited because you are always shooting 60/30/24 fps per second (or some variant of those frame speeds). There are limits on the slow and fast speeds. Consider this:

1. **Slowest speed is 1/30 second.** Do the math for 30 fps—divide one second by 30 and you get 1/30. You cannot fit thirty frames into a second at any slower shutter speed.

2. **Fast shutter speeds don't look right.** Another math problem: Suppose you shoot at 1/500 second at 30 frames per second. Your use of that second is 30/500, so what happens to the other 470/500? This shows up as gaps between each shot, making movement stutter and jump. Movement does not look normal or natural.

3. **1/60 second.** Some folks feel that the ideal shutter speed for video is one over twice the frame rate, so this would be 1/60 second for 30 fps. Many video pros feel that you can use a range of shutter speeds from 1/30 to 1/90 second for most video shooting (and even 1/125 second for slow moving scenes). Having a range of shutter speeds gives you more options in how you set your exposure. (See Figure 1.5.)

4. **Fast shutter speeds can be used for action you want to examine.** There is a place for fast shutter speeds and video. When you want to stop your video and examine fast action in that video, such as a golf swing, then fast shutter speeds will help because each frame will be sharper. The normal video shutter speed of 1/60 or so will not stop fast action, though it does usually look best for continuous playing of video.

Figure 1.5
A good shutter speed for video is 1/60 second.

If you have such a narrow range of shutter speed options, what can you do to adjust f/stops? You have two options depending on the light.

- **Neutral density filter.** You can get a neutral density filter to screw into the front of your lens to block some of the light. This will allow you to use wider f/stops in bright light. You will find more about this in Chapter 3.

- **Boosted ISO sensitivity.** When the light starts to drop, a neutral density filter is not going to do you much good. Then you have to change your ISO setting. You will be using your ISO setting much differently than you might when you're shooting still photos. For video, you are going to change ISO as needed in order to deal with the limitations of shutter speed.

Your Zoom Might Not Be What You Expect with Video

With a dSLR and a zoom lens, you might think that you could just zoom the lens in and out while shooting to get some of those effects that you have seen done with traditional video cameras. Unfortunately, this might not work with your zoom lens. Most zoom lenses for dSLRs are not made for continuous shooting so you sometimes will get an exposure change as you zoom your lens in or out. That exposure change can cause a flicker in light that can be very annoying in the video.

Moreover, your zoom lens probably doesn't zoom in a linear way: if you rotate the zoom collar at a constant speed, the rate of the zoom may not be constant. You don't notice little jumps in the zoom effect when shooting stills, but if you zoom during a movie shot, the effect will be noticeable.

Many zoom lenses are built to be compact, and in compact designs, the aperture actually varies as you zoom. Notice the way your zoom is listed, such as 18-55mm f/3.5-f/5.6. That means that the zoom is f/3.5 at 18mm and f/5.6 at 55mm. That is not a problem when you are shooting still photography, but it is a big problem if you try to zoom that lens while shooting video. You will see a shift in exposure as the camera tries to compensate for this change in f/stop.

The solution to this is simple. Don't zoom with such a lens while you are recording video. Do your zooming before you start the shot. (See Figure 1.6.)

Figure 1.6

Compact zoom lenses are very popular, and for good reason, because they offer much flexibility in a small package. However, they are not designed to be zoomed while recording video.

Autoexposure and Auto White Balance Challenges

Autoexposure and auto white balance can be great features of digital cameras. They can enable you to get good shots in almost any condition. They do cause a problem for video, however. Video is rarely made up of one shot. Video is typically made up of a number of shots that are edited together for a final video movie. When you watch video on television, whether that is on a news program or on a sitcom, you will see a variety of shots that show different details to better help tell a story about the subject.

When you're shooting individual still photos, a slight variation in exposure from one shot to another or even a variation in white balance is not such a big deal. When you're putting a bunch of shots together with video, that change can be a big deal. It is distracting to watch video of a kid's soccer game, for example, and see the video go from dark to light to dark again. It can also be distracting if one shot is warm and then the next one is cool in color and then the next one is warm again. (See Figure 1.7.)

This means that very often you will get the best results with video if you shoot with manual exposure and manual white balance. Try to set an exposure and white balance that will work for the entire time you are shooting. (See Figure

Figure 1.7 A problem with auto white balance is that it is inconsistent, which will be a problem when shooting video.

1.8.) This will keep the shots consistent as you change your angle to the subject, change your zoom focal length, and so forth. Here are some tips on doing that:

1. If you are comfortable shooting with autoexposure, check to see what the camera wants to set for a basic exposure for the scene then transfer those settings to your manual exposure adjustment.

2. Check your camera manual to see how to use your camera's particular exposure scale for getting the best manual exposure.

3. You can take a still photo with the manual settings you have chosen for your video and then check it for exposure by using the histogram and overexposure warnings. You want exposure that is as bright as possible without getting overexposure warnings in important parts of the picture and without cutting off the right side of the histogram.

4. Choose a white balance setting that matches your conditions. For example, if you are shooting during the day and in sunlight, then choose the Daylight white balance setting. If you're shooting in the shade, choose the Shade white balance setting. If you're shooting under florescent lights, then choose the Fluorescent white balance setting.

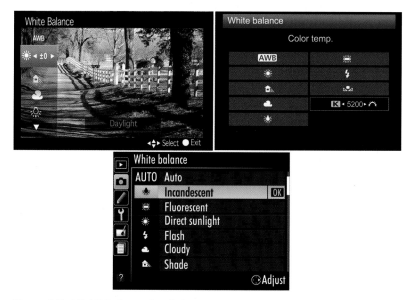

Figure 1.8 All dSLRs have white balance settings. You can select a preset value, dial in an exact color temperature (if known), or use a custom white balance.

Better Sound from the Start

The sound or audio of your video is very important to the overall impact of your video. People are strongly influenced by what they hear when watching video and this affects how they see what is actually being shown. Bad audio can make good video look bad. You'll find more information on getting better audio in Chapter 6.

To get started with getting the best audio you can, there are some things that you can do right away:

1. Get your camera with its microphone as close to important sound as possible. If you are far away from a sound, the microphone will pick up all sorts of extraneous sounds you don't want. (See Figure 1.9.)

2. Listen carefully to the setting where you are recording video. The lens only sees what is in front of the camera, but the microphone will hear things all around you. Be aware of those sounds so that you can move away from problem sounds or record when things are quieter.

3. Turn off your camera's microphone when the sound is bad. You don't want to record bad sound with your video if you can help it.

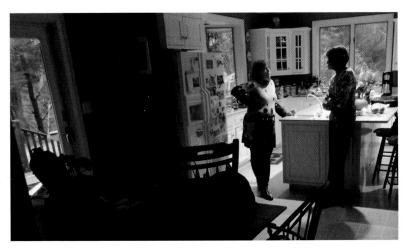

Figure 1.9 The sound you record with video will have a big effect on the final results.

Basic Shooting Tips

You will learn many different ways to shoot better video throughout this book. To get you started, however, here are some tips that will help you make the transition from shooting still photography to capturing movement and time in video.

1. **Shoot at least 10 seconds per shot.** When you're shooting video, you are not creating a bunch of still photos for a slideshow. You need to be sure that you have enough video to capture important action and to give you options when you are editing a video. A 10-second minimum is very helpful.

2. **Think shots, not shot.** A big difference between still photography and video is that video works by many shots put together in editing, compared to the single shot of still photography. And think variety for those shots. You need a variety of shots for editing, from close-ups to distant shots. (See Figure 1.10.)

3. **Find and use movement.** Video is a moving medium so look for movement in your shots. Even if the movement is very subtle or you have to wait for some action to occur, actively look for that because motion will add interest to your sequences when you put your video shots together.

4. **Deliberate movement.** If you create movement by zooming or moving your camera, make sure that it is deliberate and for a specific purpose related to the shot and the subject.

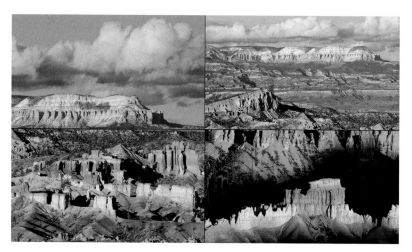

Figure 1.10 With video, your goal is to shoot a variety of shots, not to look for the one good shot.

5. **Avoid constant movement.** If your camera is always moving, including zooming the lens in and out, you will make your viewers seasick rather than helping them enjoy your video.

6. **Remember that shutter speeds are different.** With still photography, you can shoot any shutter speed you want. With video, the optimum is around 1/30-1/90 sec. You can use higher shutter speeds for special effects, but the video can look choppy. You cannot shoot normal video at slower shutter speeds.

7. **Use a neutral density filter.** A neutral density filter can be critical for shooting in bright sunlight in order to deal with the slower shutter speeds of video.

Chapter 2

Typical Controls

Your dSLR has a number of standard controls for video that you should know about. Unfortunately, there is no standard for how these controls are arranged on your camera body or in the menus. You may have to look for them in your manual or with hints that are provided here. One thing to be aware of is that many cameras turn off access to video controls when you are shooting still photos. If you look for video controls as you photograph, you might not see them if this is true for your camera. Many cameras will only allow you to set video controls when the video function is turned on.

Turning Video On

Typically you will turn the video function of your camera on or off with a button, switch, or dial on the body of your camera. The way that you find this particular control is to look for the small video camera icon that looks like a rectangular box with the lens on the left and two legs of a tripod sticking out of the bottom. (See Figure 2.1.) A separate control is probably used to begin/end actual video shooting. Most vendors have settled on a button marked with a red dot (see Figure 2.2).

Figure 2.1
Look for this video icon to show you how to turn the camera's video function on or off.

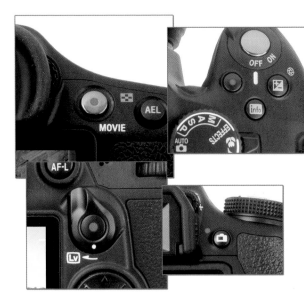

Figure 2.2

Video capture may be turned on and off from a dial, a switch, or a button, often marked with a red dot.

When you set your camera to record video, several things happen to your camera:

- The mirror of a dSLR flips up to allow light to hit the sensor directly from the lens. (Some cameras, such as Sony's SLT line use a translucent mirror that doesn't flip up, and many interchangeable lens, non-dSLR cameras are entirely mirrorless.)
- The sensor turns on in order to capture what is coming through the lens.
- The display turns on to show you what the sensor sees coming through the lens.

One tip to consider—when you're waiting to shoot video but don't need the camera on, you don't have to turn the camera all the way off. Simply turn the video switch or dial so that it is on a still photography setting. That will turn off all of the things related to video but keep your camera functional so it is ready to shoot faster.

Choosing Video Resolution and Frames Per Second (fps)

As discussed in the last chapter, you may or may not have some choices as to what resolution to use when shooting video. The default setting for your camera will work well for most video recording. However, if you need to change

this, you will typically find video resolution options within the menu system of your camera. On most cameras, this video resolution will be available in the shooting menu. However, some cameras will not allow you to access this option unless the camera is set to record video.

Frames per second are usually in the same place as the options for video resolution. Sometimes the only options you will have for changing frames per second are if you change video resolution. Again, the default setting for your camera will work well for most video recording. (See Figure 2.3.)

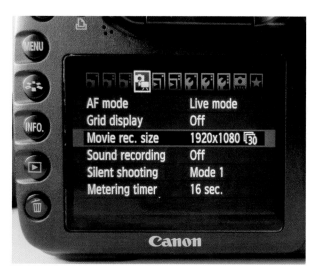

Figure 2.3
You will usually find video resolution and frames per second in the same menu item in camera menus.

Turning Audio On or Off

Audio is an important part of video, but sometimes the conditions in which you are shooting are just not right for audio. Having bad audio with your video can result in a "defect" that prompts you to delete a sequence which otherwise really does not need to be deleted if the audio is removed or replaced.

Audio for both internal and external microphones is usually turned on or off from a camera menu, most often a shooting menu. You may have other options, such as manual or automatic volume control or a wind noise reduction setting. (See Figure 2.4.) For now, leave audio on automatic and only use the wind control if it truly is windy.

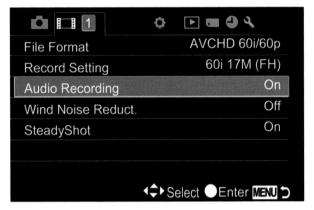

Figure 2.4
Turn your audio on or off from a camera menu.

Setting Exposure

As noted in Chapter 1, exposure considerations are different for video. The basics of exposure don't change. Your camera's meter will look at the scene and try to figure out an exposure that will render the tones and colors properly. Modern autoexposure is very good at doing that. The challenge is that autoexposure is constantly changing to adapt to any light variation that might be in the scene. That change can also occur simply by changing your camera position or zooming in or out because the camera sees more or less of a bright area or a dark area. Slight exposure changes when you are shooting individual images are not such a big deal. Exposure changes when you are trying to put together a group of images, which is what you are doing with video, can be a problem, because they can be very distracting to the viewer.

Figure 2.5
Your camera has many choices for exposure with still photography, but many of them may not work with video or are not appropriate.

So a challenge that you are going to have is to choose whether you shoot manual or autoexposure. How much control you have over exposure will vary from camera to camera. Some cameras give you a great deal of control, while others give very little. Your only option might be a generic autoexposure and if that's so, that's what you will use. Or you may have a choice between autoexposure and manual exposure. On some cameras, you may even find that you can use a variety of exposure modes that are available for still photography. However, you have to be really careful about using those autoexposure modes even if they are available. As you gain practice, you'll discover that some may not work well for video.

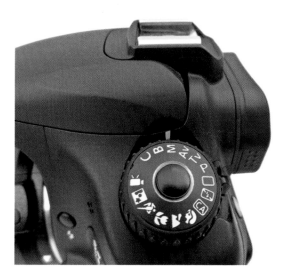

Figure 2.6

Manual exposure lets you set shutter speed and f/stop, but more important, it allows you to lock exposure to one setting as you shoot video.

If you can shoot manual exposure, then choose that option. Your camera will have some sort of scale that will tell you if exposure is correct for a scene. Now one thing you don't want to do is constantly change this exposure as you shoot video of the scene. Once you set an exposure for a particular scene in a particular light, then leave your exposure and do not change it again until you go to a different location or the light changes.

If you choose autoexposure either because you are uncomfortable with manual exposure or that is your only choice, then you need to be careful about how the camera is handling that autoexposure as you shoot. Be aware that a large bright area that suddenly appears in the frame can over influence the exposure meter. One thing that is good about shooting video is that you are constantly aware of what the video looks like because it shows up on your LCD. Pay attention to see if the image starts dramatically changing.

There Is No RAW for Video

Many still photographers have enjoyed using RAW files for their photography, which allow more adjustments in the computer. For example, you're able to bring out more detail in dark areas and bright areas as well as make many enhancements to contrast and brightness.

Video does not shoot with RAW files so you do not have this flexibility in processing the image after you have shot it. This means that you have to be careful with your exposure while you are shooting video because you don't have a lot of flexibility to adjust it later. You can make some slight adjustments to a video image in video-editing software, however, the amount of adjustment is very limited before you start to experience problems with the tonalities or color of the video.

You especially have to be careful of overexposure for video. Overexposure very quickly washes out detail in the brightest areas and leaves those areas as empty white spaces in your composition. Because overexposure is a problem, some photographers think that they should then underexpose the video. Under-exposure causes problems with dark, muddy tonality and color in the dark areas, plus you will increase the visual noise or graininess in the image.

Choosing ISO Settings

Choosing ISO settings for video is the same as choosing ISO settings for still photography at first. (See Figure 2.7 for the settings screen of a typical camera.) You want to choose your ISO settings for very specific purposes and you

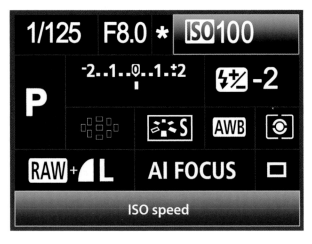

Figure 2.7
You will need to adjust your ISO setting more frequently with video than you would with still photography.

want to ensure that you do not use an elevated ISO setting not really needed for the lighting conditions. In addition, avoid using auto ISO settings. If your ISO is constantly shifting, you can have changes in visual noise which can show up as unwanted changes between scenes that you're using for video.

There are some guidelines for choosing ISO. However, these guidelines have to be tempered by the technology of your camera and the size of the sensor. Newer cameras with the latest sensor technologies will have reduced noise at all ISO settings. Larger sensors when compared to a smaller sensor of the same era will have less noise as well.

■ **Low ISO settings.** For any camera, an ISO of 100 is low. However, you may find that on certain cameras, the attributes of low ISO apply to ISO settings as high as 400. Low ISO settings mean minimal noise and the best in color and contrast for rendering a scene. Use these settings when you are shooting outdoors during the day and whenever you want the best image quality your camera offers. When light levels drop, the lowest ISO settings may not allow the optimal exposure settings in terms of shutter speed and f/stop.

■ **Moderate ISO settings.** Typically, a moderate ISO setting is from 400-800. These settings generally create only moderate noise and still render color and contrast quite well. For many situations, you will probably not notice a difference between these and lower settings. However, these are settings that you cannot easily use in bright light when shooting with video because of the restriction in shutter speed. They may encourage you to inadvertently use a faster shutter speed than you should. These are definitely good settings for lower light levels outdoors and bright conditions indoors.

■ **High ISO settings.** You may find that certain cameras with large sensors and the latest in sensor technology will allow you to go to higher ISOs and still get reasonable image quality. In general, high ISO settings result in noticeable amounts of noise and a drop in color and contrast for rendering a scene. Use these settings when you are shooting outdoors in very low light, such as on a city street at night, or indoors when the light is low.

With some cameras you will have the ability to change the increments of ISO settings. You may be able to set the increments to change ISO by 1/3, 1/2, or 1 f/stop. Because of the need to change ISO to deal with the challenge of the limited shutter speed range possible with video, you will generally find that at least 1/2-stop changes work well. If your ISO changes by a full stop, you may find that too limiting for your choice of f/stop.

Setting White Balance

For digital photographers, white balance seems rather new because it was never part of film photography. However, white balance has actually been around for video ever since video was shot in color. Video has always been electronic and can be readily adjusted so the color in the image matches the balance of the lighting conditions. That's essentially what white balance is, matching a camera's ability to record color to the color of light.

There are good reasons to choose a specific white balance rather than using auto white balance even when shooting still photography. However, auto white balance keeps getting better and better and will work well for many photographs. Unfortunately, there are some inherent problems with auto white balance that make it ill-suited for video. Auto white balance is designed to change depending on how the scene changes in front of the camera. This can mean slight changes in color of the image as you move around the subject while photographing it. This can even mean a change in color as you zoom your lens in or out to a subject. (See Figure 2.8.)

Figure 2.8

Auto white balance tends to be inconsistent, which is a problem when you are shooting video.

With still photos, white balance can be corrected in your image editor. When you are shooting multiple shots put together for video, this can be a big problem because it means you have to constantly adjust your shot color in your editing software. That can be a real nuisance besides being a challenge to do at times. If you don't do it, you will discover some very annoying color variation in your video, and your audience will notice it, too.

You will have a much easier time editing your video if you don't use auto white balance. Use a specific white balance for the conditions as long as you continue to shoot a scene in the same environment. Every dSLR has a variety of preset white balance settings that you can choose, plus you can choose a specific Kelvin temperature or even set a custom white balance for a unique situation. (See Figure 2.9.)

Here are some ideas on how to choose a white balance:

■ **Match your white balance to the conditions.** Use a Daylight white balance for a sunny day, Shade for shade, Cloudy for a cloudy day, Tungsten for general indoor lighting, and Fluorescent for an area lit with fluorescent lighting. Some cameras add more choices, but these tend to be pretty intuitive and you can simply match those choices to the conditions. When you match your white balance to the conditions, neutral grays will look basically neutral gray and colors will not have a color cast.

Figure 2.9

Know where your white balance options are on your camera and use them to match conditions.

■ **Choose a white balance that gives a slight warming or cooling to the scene.** The best example of this is when shooting at sunrise or sunset. In those conditions, there is a natural color cast that you don't want to get rid of. Auto white balance will cause problems here. Sunrise and sunset colors often look their best when captured using Cloudy white balance, which will warm them up compared to Daylight. Another example of this is shooting at night in a city. Although technically Tungsten is more accurate for the way that it deals with colors, it can make a city scene look rather cold. Changing this to Daylight can add warmth to the scene that will often look more natural. If you want to "cool" a winter scene, for example, you might experiment with the Tungsten setting, which would make the overall scene look very blue indeed.

■ **Watch your LCD as you change your white balance settings.** Since the LCD is always on while you are shooting video, you can get a good idea of how your camera is going to interpret that scene by watching the colors change as you change the white balance setting. You can decide to make the scene look neutral or slightly warmer or slightly cooler depending on the desired mood for the image.

■ **Try the Kelvin temperature settings.** Kelvin color temperature is the system of specifying color in degrees, usually from 2500 (indoor illumination) to 10,000 (extremely "blue" outdoor lighting, such as the open sky). Thus, adjustments using a camera's Kelvin settings is aligned with the warmth of light from amber to blue. There are certain situations in which adjusting on this scale can really help you get a better white balance. It definitely helps to use your LCD as you do this. White balance is not just Kelvin temperature—there is also a green to magenta bias scale that is affected, so you may not get a good white balance in conditions that have a lot of green, such as fluorescent lighting or a stream in a forest. However, Kelvin temperature is often very useful when there is a high amount of blue light coming into the scene, such as in the shade under a pure blue sky high in the mountains.

Focus Options and Challenges

dSLRs vary in their ability to use autofocus when shooting video. Some cameras will autofocus continuously while shooting, some cameras will autofocus only as you start shooting video, and some cameras will not autofocus at all so you have to use manual focus. Manual focus can be a challenge because you are focusing on a small LCD. (See Figure 2.10.) That doesn't mean that autofocus is automatically better if you have it. Sometimes autofocus will change focus to the wrong part of the scene as you are recording.

Figure 2.10

Focus is important for any visual medium, but it can be challenging to focus with your LCD while shooting video.

Here are some options for you to consider for getting better focus with your video when using autofocus:

■ **Start your autofocus before you start shooting your video.** You need the camera to lock focus and follow focus before you start recording, or part of your scene will be out of focus. Cameras vary in the way they start autofocus. With many cameras, you have to press the shutter button lightly to start the autofocus, even in video. On other cameras, there is a dedicated AF or autofocus button on the back of the camera.

■ **Choose a wide area of focus points in which your subject is dominant in the frame and clearly separated from the background.** This allows the autofocus system to always find that subject.

■ **Set your focus point or points to the most important part of your subject** so that your camera will more easily follow the movement of that subject. If your subject is moving all over the frame, then use focus points that use the entire image area. If the subject is staying in one area, then use a focus point for that area. Not all cameras have this ability.

■ **Watch for unwanted focus changes** while you are shooting, then adjust your framing so that the autofocus will again focus on your subject.

Here are some options for you to consider for getting better focus with your video when using manual focus:

■ **Pre-focus your camera where the important action is happening.** Don't try to focus while you are shooting unless the action is continually moving around. You can also pre-focus your camera on where you expect action to be. This is a common sports photographer technique; focus on the play at second, the shot on goal, or a pass receiver's pattern to be ready for when the action occurs.

- **Magnify the LCD to ensure that you are focused optimally on your subject.** Sometimes it is difficult to determine if focus is sharp on the LCD. By using the LCD magnification function of your camera, you will be able to focus much more readily on a part of the scene. Remember to set your magnification back to normal when you start to shoot video.

- **Get a magnifier for your LCD.** There are many manufacturers who now make magnifiers that will mount to your camera so that you can magnify your LCD as you shoot video. This can help you find sharp focus easier. (See Figure 2.11.)

- **Consider an accessory LCD or LCD viewfinder.** While these accessories can be expensive—$100 and up—they do offer many features that make focusing much easier, including a larger LCD or magnified high-resolution LCD as well as LCD enhancements to show when things are in and out of focus.

Figure 2.11
A magnifier can help you get better focus when using your LCD.

Avoiding Bouncy Video

One thing to keep in mind about video is that you are shooting over time. When you are shooting a single image, you are taking one picture and that picture never moves. Because you are shooting over time with video, movement can be very important, both good and bad.

Following a moving subject can be a very good use of video. However, movement of the subject is one thing. A camera that is bouncing around as you shoot is something entirely different. This can be very disturbing for your audience. (See Figure 2.12.) At the minimum, it can be annoying, but for some people, it can actually make them feel a bit seasick.

Figure 2.12
A moving camera might provide interesting effects for still images, but it can make your audience seasick if you aren't careful.

Here are some ways to avoid movement problems.

- **Move your camera deliberately.** Know why you are moving the camera and move it for a specific purpose that will be clear to the viewer.

- **Use a wide-angle lens when you're moving your camera.** Wide angles minimize small movements that can be very annoying. A telephoto will magnify them.

- **Support your camera whenever you can.** Remember that you can get away with shooting hand-held for a still photo because it is just one photo and you can shoot at a fast shutter speed. Since you're shooting over time with video, a hand-held camera shot will start to look very jumpy.

- **Use image stabilization or vibration reduction lenses.** These lenses are designed to remove some of the camera shake that occurs when a camera is hand-held. Image stabilization was originally designed for video to smooth out movements that occurred with a hand-held camera. Image stabilization continues to work well for this purpose.

- **Use a monopod.** A monopod supports the camera while shooting and helps keep it more stable. If you are holding a camera for any length of time, your muscles can begin to shake, causing additional problems with video. A monopod prevents that.

- **Use a tripod.** The tripod will always give you the most stable shooting platform for video.

- **Use a fluid head with your tripod.** Standard photography heads don't work very well with video. They move either too easily so that the video image looks like it is flopping around or in too jerky a manner. A fluid head is a special head for video that dampens movement so that it looks smoother as you move the camera to follow action or simply to pan across a scene.

Video and Great Features of Digital SLRs

Many professional videographers and filmmakers have switched to dSLRs for video because the dSLR offers some neat features that are not always available with traditional video camcorders. The biggest advantage of dSLRs with video is their ability to use interchangeable lenses. This opens up so many opportunities for you to go beyond the capabilities of a camcorder.

Close-Up Photography

With the dSLR and video, you now have access to all sorts of accessories for shooting close-up and even macro video. You can get a macro lens for your camera which will allow you to focus extremely close to your subject, making your subject as large on the sensor as it is in real life. (See Figure 2.13.) You can also purchase extension tubes that will fit between the camera and your lens so that any lens can be used to focus down to close and even macro distances. Extension tubes are a good way to get started with close-up work; they are much less expensive than macro lenses and they are extremely rugged and durable because they have no optical elements in them. They work best with moderate to telephoto focal lengths—they don't do as well with wide angles.

Another option for high-quality close-up photography is to use an achromatic close-up lens. These are highly corrected close-up lenses that screw onto the front of your camera. These are not the same as the inexpensive, three-filter close-up lens packages. Canon makes some achromatic close-up lenses, the 250D and 500D, that can be purchased to screw onto the front of almost any lens, from any manufacturer.

Figure 2.13
Video with a dSLR offers great opportunities for close-up work.

Shallow Depth-of-Field Focus Effects

dSLRs have a significantly larger sensor than what is used in standard video camcorders. As sensors get larger, focal length must also increase in order to maintain the same angle of view. As focal length increases, depth-of-field decreases for any given f/stop. The result is that with a standard video camcorder, focal lengths are shorter—they are decreased to such a degree that there tends to be a lot of depth-of-field almost anytime you shoot. That's fine if you want a lot of depth-of-field, but if you want to limit your depth-of-field and create unique shallow depth-of-field effects, this is very difficult to do with a standard camcorder.

This is one of the features of a dSLR for video that professional filmmakers really like—being able to put a subject sharply in the frame and yet the background is largely out of focus. (See Figure 2.14.) You have this option with the dSLR because you can use a wide f/stop (small number such as f/2.8) for less depth-of-field or a small f/stop (large number such as f/16) for more depth-of-field. In addition, dSLR systems often include single focal length lenses that have very wide maximum apertures, such as a 50mm f/1.4, an 85mm f/2, or a 200mm f/2.8. These allow for even more selective focus effects.

Figure 2.14
Shallow depth-of-field is easy to accomplish with a dSLR and video.

Special Focus Effects

You may have noticed a special effect where focus is on one part of a scene and not the rest, with both the foreground and background out of focus. In sequences that are shot from a moderate distance, such as people that aren't far away, this gives a unique look and emphasis to the people. When this technique is used for big scenes, such as a city or a landscape, it can make it look like the scene is a miniature model rather than the actual scene. Indeed, some cameras today have what is called a Miniature Effect or Tilt-Shift Effect to provide this.

These effects can be done optically with something called a tilt-shift lens, which is available from many camera manufacturers. With such a lens, you tilt the lens itself in its special mount to change the plane of focus. This can be done to move the plane of focus around, depending on how that plane of focus is tilted with the lens.

The Lensbaby system of soft-focus lenses offers an alternative to the tilt-shift lens. Lensbaby lenses create a more dreamy soft-focus effect and will change where the sharpest focus is.

Extreme Wide Angle

Almost all dSLR camera systems include the possibility of extreme wide-angle focal lengths. These focal lengths have traditionally been unattainable with video camcorders. Such a wide-angle look in video, therefore, can be quite unusual. By shooting your own video with a wide-angle focal length, you immediately gain a unique look.

Extreme wide-angle focal lengths change the way things move through the frame of video. Things will appear to move at a different speed at the edges of the frame or close-up compared to the middle or far away. This is simply because of the way wide angles see the world. This effect is especially pronounced when you pan your camera across a scene or you tilt your camera up and down. This will give you an extreme effect that can really grab your audience's attention, but it can also be so extreme that it is distracting. Try different ways of moving the camera across the scene, or even as you move the camera into and around the scene. Extreme wide angle will minimize any bouncy movement and give you some very interesting looks. (See Figure 2.15.)

Figure 2.15

Extreme wide-angle shots simply were not possible with traditional video. They are with a dSLR.

Fisheye Lenses

A fisheye lens is a unique extreme wide-angle lens that provides a very wide angle of view and curves straight lines for a very distinctive look. (See Figure 2.16.) Fisheye lenses cover such an extreme angle of view that you have to be careful that you don't pick up your feet or tripod legs in the shot. This is less of a problem with video, because you aren't getting the full depth of a dSLR's image area.

The name full-frame fisheye is somewhat misleading because it seems to imply that this is a lens for a full-frame digital camera. That is not true. The full-frame fisheye lens has actually been around longer than digital cameras. Such lenses are available for most digital camera formats.

A full fisheye is a lens in which an image fills up the entire visual area. There are also fisheye lenses that produce a circular image that fits inside the overall frame. Either one can be used when shooting video for a unique effect. Although you will clip the top and bottom of the image circle produced by a fisheye lens that is not a full fisheye.

Figure 2.16
A full fisheye gives a unique look to video.

Chapter 3

Important Accessories

As you read through the first two chapters of this book, you found some recommendations for important accessories, including a tripod, extra batteries, and a little about memory cards. In this chapter, you'll learn a little bit more about these accessories and why they can be so helpful to you when you are shooting video.

Have Enough Batteries

Remember that your camera is using a lot more power when shooting video. Your camera battery has to power the sensor and the LCD, just to start; then it has to power the internal processor of your camera as it converts images from your sensor into video and then records onto a memory card.

So when you plan to shoot video, be sure that you have fully charged batteries and enough batteries. If your camera runs out of battery power while shooting video, that can cause big problems with the files on your memory card. You may find that you cannot read the files on your card, meaning that everything that you had shot might be lost.

How long a battery will last with video is dependent on a number of things:

- **The size of the battery.** Many of the very compact digital SLRs have rather small batteries. It is true that modern battery technology does give a lot of power to the small batteries, but still a smaller battery will last less time than a larger battery.
- **How long you leave your camera on in between shots.** As long as the camera is on and ready to shoot, the sensor and LCD are also on and using power. If you turn your camera off, or at least off of the video setting in between shots, your battery will last longer. (See Figure 3.1.)
- **Image stabilization features.** If you are using image stabilization or vibration reduction features on your lens, that will also be a power drain on your battery.

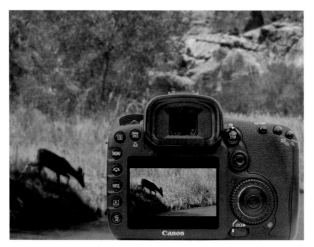

Figure 3.1

When you leave the camera on in video mode, both the sensor and LCD are powered and this will shorten your battery life.

- **The battery itself.** You may find that older batteries, perhaps one you have left over from a previous camera that used the same type, even if they fit your camera, simply do not have the lasting power of a new battery. In addition, some off-brand batteries—batteries that are not made by the camera manufacturer—might not retain power as well as the manufacturer's batteries.

This makes it difficult to give a specific recommendation related to what you can expect for video recording and your camera's battery. However, most dSLRs will shoot at least 20 minutes of video from a single, fully charged battery. Make sure that you have multiple, fully charged batteries ready to go so that you do not run out of power as you are shooting. Consider having at least three batteries for your camera if you intend on shooting much video.

Enough Memory Cards

As noted in Chapter 1, video uses up memory card storage in a hurry. You will discover that when you are shooting video, you can quickly fill a card with 20 minutes of video. Be sure you have enough memory cards or large enough cards to handle your video shooting as well as any still photography you might be doing.

Anything less than an 8GB memory card will be a nuisance to use because you will be forever running out of space when shooting video. dSLRs will typically shoot anywhere from 20 to 30 minutes of video on an 8GB card, though again, this will vary depending on the resolution, frame rate, and compression.

Most dSLRs will use either CompactFlash or SD cards. That is determined by the camera—you have to purchase the right type of card for your camera. Three or four 8GB cards or a couple of 16GB cards can be well worth having and using. (See Figure 3.2.)

And be sure that you get a fast enough memory card. Look for a minimum transfer speed listed on the card of 15MB/s. You will generally have good results with a Class 10 SDHC card or UDMA high-speed CompactFlash card. These offer speeds above 15MB/s. You should not have to search for the speed—all major memory cards now have the speed listed on the top of the memory card itself. A caution: some very cheap memory cards may appear to be rated at the correct speed, but they may not keep up with video from your camera. Some vendors of off-brand cards exaggerate the speed of their products, to put it politely.

Figure 3.2

Without the right speed for your memory card, your camera may have trouble recording video properly or at all.

ND Filter

Remember that with video, you have a narrow range of shutter speed options. This can make it extremely challenging for shooting in certain conditions, especially if you want to take advantage of wide f/stops for limited depth-of-field effects. With just 1/30, 1/60, and 1/90 as your primary shutter speed choices, your f/stop options are minimal, especially in bright light.

If you want to take advantage of a wide range of f/stops, get a neutral density filter. (See Figure 3.3.) A neutral density filter is simply a dark filter that cuts down the amount of light going through your lens. This allows you to use wider f/stops (smaller numbers) to better control depth-of-field as needed when the light is bright. Generally, a neutral density filter that cuts the light by three f/stops is a good strength. Such three-stop filters will be given either an ND8

Figure 3.3
A neutral density filter is simply a dark gray filter that cuts the light going into the camera.

or ND9 designation (using the two most common ways to specify the light-stopping power of a neutral density filter).

Some photographers use a variable density neutral density filter for this purpose. This is a filter that is built with two filters—one filter rotates in front of the other and gives an infinite variety of darkness for the filter.

If you don't have a neutral density filter, and you do have a polarizing filter, you can use that polarizing filter to cut the light by almost two f/stops. That won't give you as much control, but it can help.

A Sturdy Tripod

A sturdy tripod is probably one of the least exciting purchases for a photographer, yet it is one of the most important investments that you can make. A good tripod is an investment. You often see photographers at major national parks with superb cameras and lenses stuck on a really cheap tripod. That really cheap tripod negates the good equipment that they are using.

Since video is shot over time, mounting your camera to a tripod means that it will stay stable over time. Hand-held video can be difficult to watch, especially if you are using any sort of a telephoto focal length. A telephoto will magnify any movement of the camera as you shoot the video.

It used to be that you really needed a heavy tripod in order to keep your camera still. That's not true today with lightweight aluminum alloys and carbon fiber tripods. If you can afford a carbon fiber tripod, make the investment. These tripods are very lightweight and extremely rigid. A solid, lightweight tripod is a tripod that you are more likely to take with you and use.

There are many good tripods on the market. Avoid buying a cheap tripod from a mass discount or electronics store. You will find the best tripods at a camera

store. Fully extend a tripod, lock the legs, and lean on it. That tripod should handle your lean without any significant give or sway. Try opening and closing the legs of the tripod. You want a tripod that is easy to open and close and one that you feel is securely locking the legs. You won't use a tripod if it is hard to use or if you think the tripod is likely to fall over. (See Figure 3.4.)

Figure 3.4

A good tripod with a fluid head is an important accessory for shooting video.

Fluid Head

The head that goes on your tripod is also very important. You could use an existing tripod that you might have for still photography, but you will need to get a new tripod head. Photographers are used to ballheads for their tripods, but ballheads do not work very well for video. A ballhead is simply a tripod head based on a ball and socket to make it quick and easy to position for shooting. When you are panning or tilting a video camera across the scene, and you will start to do that when you're shooting video, a ballhead does not hold its position well enough to provide smooth movement.

Pan and tilt heads have handles that stick out of the back and the side and allow you to tilt your camera up or down, left or right, and so forth. These can be very good heads for still photography, but again, they are not designed for smooth movement and can cause rather jerky looking pans or tilts across a scene as you shoot video.

For the best video shooting, you need what is called a fluid head. A fluid head uses hydraulics inside the mechanism of the tripod head to dampen movement as you pan or tilt your camera across the scene. There are some inexpensive video heads that use a friction mechanism to provide the same effect, although these can be harder to set for smooth movement.

Fluid heads range quite a bit in price. But even the cheapest fluid heads will do a better job with video than a ballhead or a pan and tilt head. If you're willing to spend more money for a better quality fluid head, you'll gain more control over the movement of that head and get smoother shots as you pan and tilt across a scene.

Fluid heads usually include a sliding plate that mounts to your camera. This is not simply a quick release plate. This long sliding plate allows you to move the camera forward or backward on top of the head to better balance it to help make your movements smoother.

Monopod

A monopod is like a single leg of a tripod. They're much less expensive than a tripod, plus they are obviously quite a bit lighter and easier to carry. They will help stabilize your camera, especially when you need to hold your camera steady yet be ready to move to follow action quickly. A monopod will not keep the camera completely still, though, especially when you are using a telephoto to shoot video. A monopod works great for shooting still photos with a telephoto (such as sports photography), but may not give enough stability for video.

For general use with wide-angle to moderate focal lengths, a monopod can be a good way to stabilize your video shooting. In addition, you can rotate the camera from side to side, or with the right monopod head, up and down, to follow action. (See Figure 3.5.)

Beanbag

A beanbag is a very handy and extremely portable device for stabilizing a camera, whether you are capturing still photos or shooting video. This is a little stuffed bag that allows you to mold it to a surface. Originally, beanbags were literally stuffed with beans. Some photographers like to travel with empty beanbags and fill them with beans that they get on location. That makes the beanbag very portable. Today's beanbags are typically stuffed with plastic pellets which make them more durable and less of a problem if they get wet.

Figure 3.5 A monopod can be used for quick and easy video shooting, though it cannot replace a tripod for stability.

Figure 3.6 Beanbags support your camera on many surfaces and are light and easy to carry.

You simply place a beanbag onto a surface and then your camera onto the beanbag. The beanbag molds around both the surface and the camera, giving you a very stable camera and lens. You can use almost anything that is sturdy for the support—the ground, a fence post, a chair, a table, a traffic meter, and so on. You do have to be careful about putting a beanbag onto a solid surface that is attached to a motor, such as a car, if the motor is on. That can transmit a vibration to the camera that will be visible in the video.

Beanbags come in different sizes. You need a beanbag that is big enough to fully support your camera and lens. There are some specialized beanbags on the market that include a tripod socket that can make it even easier to hold your camera in one position. (See Figure 3.6.)

Shoulder and Chest Rigs

You may have seen all sorts of fancy rigs that you can put your camera in and on to support the camera on your shoulder, your chest, or in front of you. Most photographers will not need all of that elaborate and often quite expensive gear. There are reasons for that gear—they will allow a photographer to mount specialized accessories, including large LCD monitors, special audio gear, and more. If you don't have that gear, then you probably don't need an elaborate camera rig.

However, one thing that can help for hand-holding a camera and getting steadier shots is to have a shoulder mount that has a counterbalance or a chest support. This can keep the camera more stable, especially as you move around. Mounts that simply hold the camera in front of you can help, but after a while your arms will get tired and you will have trouble keeping the camera steady. With a counterweight on a shoulder mount or a shoulder mount with a chest support, you don't have to support the camera and lens weight just with your hands and arms. This allows you to move quickly and easily through an area as you shoot stable video. (See Figure 3.7.)

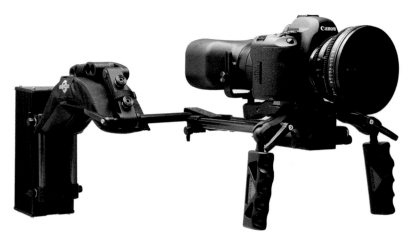

Figure 3.7 Shoulder rigs offer unique ways of stabilizing a camera for video shooting, but not every photographer needs one.

External Microphone

The microphone (or mic) built into your camera is okay but not great. The camera manufacturer is not primarily concerned with audio. After all, a dSLR is specifically designed for shooting still photos. You will probably have to look very carefully on the camera body to even find the tiny openings for the microphone. Compare this to the microphones built into a camcorder where careful attention has been made to recording audio. Those mics, even on an inexpensive camcorder, are huge compared to what is on a dSLR.

Even if the camera manufacturer used a good mic in the camera body, there are some real problems with having a microphone built into the camera body itself. Microphones that are built into a camcorder are very carefully placed and

mounted to optimize sound coming to the mic and minimize sound that comes from the body of the camera itself. Unfortunately, this is not true for mics built into a dSLR. Those microphones really emphasize noises from the camera and lens, and they are not optimally placed to get the best sound from your subject.

The answer is to get an external mic. Here are two types of microphones to look for. Make sure your camera allows you to plug in an external microphone. Unfortunately, some camera manufacturers do not include a mic jack and so you are forced to accept audio from the internal microphone.

■ **Shotgun mic.** You can find shotgun microphones that will slide into the hot shoe of your camera and then plug in to the microphone jack. These microphones limit the area of sensitivity so that you can better pick up sounds from your subject rather than extraneous sounds coming from one side or the other. In addition, they have a small shock absorbing mount so that camera noises are not transmitted to the microphone. (See Figure 3.8.)

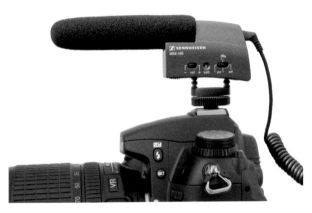

Figure 3.8

A shotgun mic limits its sensitivity to a narrow angle to better capture audio in many conditions.

■ **Lavalier mic.** Lavalier microphones are the small microphones that you see clipped to people being interviewed for news and documentary stories on television. You can get these little microphones so that you can clip them to your subject's collar or somewhere near their face and then plug the cord into your camera. Since a lavalier microphone is so close to the person talking, your camera will better record that person's voice and minimize any extraneous sounds. (See Figure 3.9.)

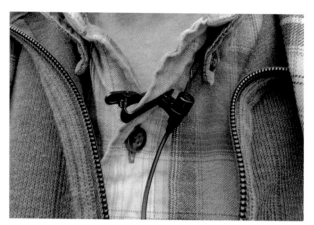

Figure 3.9
A lavalier mic captures better audio by being close to the sound.

Chapter 4

Planning and Shooting Your Movie

Once you have enough batteries, sufficient storage in memory cards, and some sort of support for your camera, you are ready to start shooting your movie. The term movie implies you are putting something together rather than just turning on your camera to shoot video. Good video is a good movie, something you will enjoy shooting and your audience will enjoy watching. In this chapter, you will learn how to do just that.

The Basic Montage

An easy way to get started shooting video is to shoot a montage of images that are edited against music. You don't have to learn a lot of new photography techniques to create a montage video. This is like a moving slideshow, in some ways, but it is also quite different. If you simply think in terms of a slideshow, you will not be as successful with video. A slideshow is meant to show off single images, one at a time. Each image is usually shot with attention to making that image "the best" you can without much consideration to how the images will go together later. Such images may have a connection, but ultimately, they usually can stand alone. Viewers know and understand this way of looking at photos.

Video is not seen that way. Video is always seen as groups of linked images that go together. They almost never stand alone, and viewers expect this when looking at video. You will not simply be looking for the "best" shot, but also shots that can work together. Here are some things to consider when shooting for a montage:

- **Groups.** Look for groups of shots rather than single best images.
- **Vary composition.** Rather than shooting the same framing of your subject from shot to shot, look for different ways of composing so that shots within a group look different.

- **Avoid having all the shots as big scenes.** You need detail shots to help your sequences flow together and to give the audience a richer viewing experience.

- **Look for movement.** Even a slight bit of movement such as a leaf blowing in the wind will help a video montage. Video is about movement and viewers like to see this.

- **Look for variety that fits a theme.** The theme will help you find groups of shots that go together, and the variety will help you immensely when you edit the montage together with music. Variety is stressed throughout this chapter because it is so important for video.

Many of the ideas in the rest of this chapter about shooting for variety and shot types also apply to shooting for a montage. (See Figures 4.1–4.3.)

Figure 4.1
Figure 4.2
Figure 4.3

A montage can be a way to get started with video, but to make the most out of a montage, you need to have good variety in the way you shoot your video.

Creating Stories

Everyone has a story. You have stories about your family, about your business, your hobbies, nature, sports, and the list goes on. Whatever it is that really interests you, you will find that you can create a movie about that. You don't have to be some Hollywood director or cameraman to do this. At the most basic level, creating a movie is simply about putting together a sequence of video and audio clips that work together to tell a story about the world around you.

Video is ideal for this. With still photography, you might capture a spectacular shot, but it is only one shot. It can be hard to put a story into a single shot; most photographers are not taught to do that. With video, you're combining motion and sound with changing visuals to create a different way of communicating compared to what you get from a still photograph.

Imagine you are watching a soccer game. (See Figure 4.4.) You can take lots of individual pictures that will give an impression of the game and show off details of the play. But all of those are frozen instances and offer no feeling of the game's ebb and flow. You cannot see how a defender chases down a striker going for the goal. You cannot see how a goalkeeper prepares for and makes a save on a breakaway from a striker. You cannot see and hear how a coach reacts to what is happening in the game. You cannot see and hear what the fans are doing. Yet with a video movie, all of these things truly come to life.

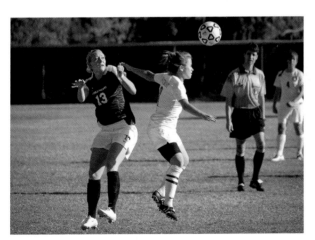

Figure 4.4

A still photo can capture a dramatic moment of action, but it can never match video's ability to show off the ebb and flow of that action.

How You Approach Shooting Photography

Photographers constantly strive to find that one best shot that represents the subject or scene in front of them. This may mean taking lots of pictures of a changing subject with the goal of getting that one shot that really shows off the action. This might also mean wandering around the subject and photographing it from multiple angles until you get that shot that is just right.

If you are interested in capturing some peak moments of action at that soccer game, for example, then you will keep shooting similar types of shots, always looking for the best action. Or maybe you are visiting a great natural location in Costa Rica, taking a boat trip through the rainforest. You are ever alert for the wildlife that the naturalist points out so you can get the shot. (See Figure 4.5.) The goal is to create an image that you can print and put up on the wall, send to someone via e-mail, post on Facebook, and so on.

Figure 4.5
A still photo can emphasize a striking subject, but video can make the subject and the story of the subject truly come alive.

How You Approach Shooting Video

Video is about multiple shots. The single shot is much less important than how a group of shots go together in the movie. Now when you are shooting video, you are going to be looking for a variety of shots, not simply a lot of shots of the same thing. It is only with variety that you can edit a sequence of video clips together to create a truly interesting movie.

Back to the idea of the Costa Rica trip. Now with video, you're going to be looking for all kinds of different shots, not just looking for the special subjects that you find. You will be looking for shots that show the boat moving down the river and through the rainforest—shots of the wildlife you see. Not just the close up of the bird or crocodile, but also shots showing the setting or even

casual movements that show off the animal's life. You will look for interesting and moving shots of water, sky, trees, other plants, maybe even the folks on the boat. All of this is done to capture a range of images that will show off what this place is really about.

It is actually easier and faster to edit a large group of shots than to try to make a small group of shots somehow go together. (See Figures 4.6–4.8.)

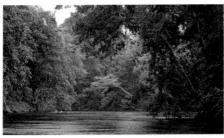

Figure 4.6
Figure 4.7
Figure 4.8
Varied shots come together in video to tell a more complete story than you get with a single still image.

Find and Shoot for a Beginning, Middle, and End

Stories have a beginning, middle, and end. That's the basic structure of a story. Being aware that you are going to need something to begin your video, end your video, and then include something in between, will help you look for the variety of shots you need when shooting video.

Just because you need a beginning and end does not mean that these are simply the first and last shots you took, then everything in between simply follows the order of your shooting. While there are some events that do indeed have a chronological order that can be important to record for story, most of the time you're going to need something that is more dramatic and unique for the beginning and end of your video than simply the first and last shots you took. That may even include a series of shots that create an interesting beginning or ending. Then you will need shots that fill out and enhance the story that you are telling about your subject.

Here are some ideas for beginning shots:

- **A dramatic opening visual.** Look for something that represents your subject and has a strong graphic design, bold lighting, or bright color. These things can grab your viewer's attention and make them want to stay engaged with watching the movie.

- **An interesting sign.** Be careful about simply pointing your camera at a sign that describes a location. That can be a real turnoff for your audience, even if that audience is only your family. A dead-on shot of a sign just looks boring and gives your audience the idea that you didn't put much effort into the movie. Find an interesting sign. Find an interesting or unusual angle to the sign. Find a sign in striking light. Find a sign with some movement in the shot (even if it is just branches blowing in the wind). Try to shoot whatever sign you are using in such a way that it is an interesting visual.

- **Bold and non-specific action.** Sometimes you will find some interesting action that represents more than the specifics of that action. In other words, you may find action that implies something about the event itself. An example of this might be a tight shot of a soccer ball with a player's feet as the ball is dribbled down the field—that doesn't have a specific context for the game.

- **Beginnings.** Since many events have a beginning, try shooting a variety of shots of that. You're not just looking for the first thing that happens. You're looking for something dramatic and interesting.

- **A scene composed for a title.** It can be a lot of fun to include a title at the beginning of your movie. A challenge for the title is having a scene behind the title as a background with contrasting, unobtrusive tones and detail that help make the title text show up well. The best way to get such a scene is to shoot for it. Shoot a scene that has some blank space in the background perfect for putting in title text, such as sky or simply an area that is out of focus. You can even deliberately shoot some out-of-focus video so that you have something to put behind the title. (See Figure 4.9.)

Figure 4.9
An interesting beginning shot can be used as a background for your title.

This may seem odd, but it is good to look for ending shots as you shoot video. The best shots for an ending are not always the last shots you shoot. In fact, sometimes the last things you see at an event are rather dull and uninteresting. Here are some ideas for things that can work for endings:

■ **A dramatic ending visual.** In the early days of film, movies would end with a title that simply said, "The End." Today's audiences, even yours, want something more than that. But the idea of something as simple as "The End," is still important. This could be as basic as a bold and colorful design that represents a location or an event. Or it could simply be something that's rather dark, though still understandable, that gives an impression of an ending. It could be something as simple as both teams of soccer players shaking hands at the end of a game, or a sunset in Costa Rica.

■ **An interesting sign.** The same ideas for beginning signs apply here. A sign—an airport sign signaling the end of a journey, for example—can represent an ending by offering some sort of completion for an event or a finish for a location.

■ **Action that slows or no action at all.** Endings need to give the audience the feeling that things are wrapped up, done. Action that slows down or something that is static compared to earlier action can offer an impression of ending. We've all seen examples of this in Hollywood productions that end with a freeze frame, or a long shot of the location where the action took place.

■ **Endings.** Things do end, and so, it can be helpful to find visuals that represent an ending to an event. Again, don't just look for whatever is the last thing going on. Look for last things that you can capture in a visually interesting way.

- **A scene composed for end credits.** You can end a movie simply by telling the viewer, "A movie by Bill Smith" or something like that. Once again, look for a scene that has some blank space for a title, but something different than what you used for a beginning.

- **Anything that has a feeling of finality.** When you are shooting, you will often come across moments or scenes that simply give the feeling that there is nothing after this. That will make a good ending. For example, if a film details the happenings of a particular day, a sunset image definitely will provide a feeling of closure. (See Figure 4.10.)

Figure 4.10

As you shoot video, also think about creating shots that could be used for an ending.

Show, Don't Tell

A lot of times people shooting with camcorders will simply walk through a scene, describing what they see as a narration for the video. They won't bother to get the important shots that really showed what was going on—they simply tell you what they saw from a distance. That's not a good way to deal with video because it really annoys viewers. People want to *see* what is important, not be told about it. Video is a visual medium.

This is where it really helps to remember you are not shooting individual photographs. You are capturing video as a variety of shots that will go together to create your movie. Since you are not after that single best shot, and since you are putting together a series of images for video, each individual shot does not have to be a beautiful, perfectly composed image. This allows you to get the shots that you need without worrying so much about making each shot perfect. It is more important to get the shot that will really show your viewer something going on than it is to have a perfect shot of that action.

It can be very frustrating to get back to the computer and start to edit your video and find out you are missing shots. You will know this immediately

because you will start wondering why you didn't get a shot showing off that action or that detail or that person—you need that shot to fit in with your sequence of other shots to build your movie. You can't go wrong by shooting too much. You can definitely go wrong by not shooting enough and hoping to compensate by your narration later.

The Narrative Story

The traditional story form is a narrative. This is what most novels are, most Hollywood movies, and so forth. These have a distinctive story based on something happening over time. The classic Hollywood narrative is one in which a hero is introduced, something happens to the hero to cause him or her to start a course of action, the hero does a series of actions that build to a climax, a dramatic climax occurs, then the narrative finishes. Something happens over time.

The structure can actually be used for almost any activity. Think about something as simple as a birthday party. The hero is the birthday girl. (See Figure 4.11.) You could start out with shots of the birthday girl getting ready for the birthday or inviting people in to the party. Then perhaps a naturalist comes to the party, which starts a course of action for the party. You shoot video of the naturalist showing off bugs and lizards and interacting with the kids at the party, and especially the hero. This builds up to a big smile on the child's face. Then the group moves to opening presents. Here again, the hero is featured as she interacts with the presents and the other kids at the party. Then there is the climax of blowing out the candles and eating the cake. Finally, the kids get their jackets on and leave as the party ends.

The key to doing this type of story is that you need the shots that can tell the narrative from beginning to end. Be sure that you have shots that feature the main subject of the movie, whether that main subject is a human being, a pet,

Figure 4.11

A narrative story typically features a "hero" that is followed through the movie. This can be as simple as the birthday girl at a birthday party.

or an endangered plant species in a forest. The main subject—the "hero"—of your movie whether it's an animate object or not, does not have to be human. A hero could be an animal, a pond, or even something like a mountain. Any of these subjects become heroes in the way that you treat them as you shoot the video.

The Event Story

An event story is a bit like a news story that you might see on television. For such a news story, there will be a lot of details about the event without a focus on a specific hero, or even on a particularly narrative timeline.

The important thing about an event story is that you look for specific details that highlight the event. In this case, you're telling a story about the event, not simply about a person in the event. If you focus on a person in the event, then it usually becomes more of a narrative story. (See Figures 4.12–4.13.)

Specificity is important. You don't want to simply show a big stack of presents at a birthday party, for example. You want to show individual presents so that you give an impression of the variety of presents that were actually at this party. You also don't want simply to show kids running around at such a party. You want to show specific kids in specific dress so that again, the viewer starts to understand the dynamics and special qualities of this event. Look for as many different and unique details about the event as you can capture. You will be creating an impression of this event through a montage of video images.

Figure 4.12
Figure 4.13

An event story uses many shots to give an impression of that event. This can be as simple as looking for specific details at a birthday party.

Details of a Person, Place, or Thing

Stories can provide rich detail about a person, place, or thing. There does not have to be an event or a narrative for you to capture these details and show off your subject to your viewers. You simply have to spend some time with your subject to explore fully what that subject is all about.

What does that mean? It means that you have to look at both the subject and its surroundings to provide a detailed background of information. Showing the viewer what a subject is, simply to provide a real or implied backstory, is not necessarily based on a narrative of something happening. Because you don't have an event as an underlying structure, you have to look for richness in detail and interesting visuals that can capture both the essence of your subject as well as the attention of your viewer.

A good example of this is trying to show off the story of a place. You might think of this as finding the sense of that place through your video. A long shot that simply wanders through a location does not give this feeling of place. Yes, that will show the place, but it doesn't emphasize important details for the viewer. It is important to include details that help the viewer focus in on what is truly important about understanding this subject. (See Figures 4.14–4.16.)

Say, for example, that you were going to show off the story of a rainforest in Costa Rica. You could simply walk on a trail through the rainforest as you recorded video. But that wouldn't reveal much about the rainforest. You could start shooting details along the trail from beginning to end. That might provide a story about your hike through the rainforest, but it still might not really present the story of the rainforest.

To present that story of the rainforest, you'd need to look for lots of very specific details. Specificity is very important in storytelling of any kind. So you would look for details of the trees, the palms, any insects you might find, flowers, any animals that you find and so forth. All of these details could then come together in a video to create a story about this place.

Planning Your Shots and Angles

As you were thinking about stories, you probably started realizing that it is going to help if you plan your shots and angles as you go. With still photography, you can often shoot rather randomly because you are only after the single best shots. With video, you need to have a range of shots that can come together to create a story and to create your movie. If you don't think about that range of shots both before and as you shoot, you will not get them and you will get frustrated when you go to edit your movie together.

Figure 4.14
Figure 4.15
Figure 4.16
Specific details of a place can be combined in video to tell a story about that place.

Variety Is Key

Because you're going to have to put together multiple shots to make your movie, you need to shoot an assortment of images. You need both variety of what is in the shot as well as variety in the type of shot to give you the best options for editing. Watch any movie or television show, watch any news broadcast or documentary, and you will see that a variety of shots are put together to make the final video or movie. All viewers expect this regardless of whether they are watching something you put together or Hollywood put together.

This does not have to be a complex thing. As you are shooting a scene, think about how many different variations of this subject or scene you can do while

you are in that spot. Can you zoom in for a close-up? Can you zoom out to show the whole scene? Can you zoom in and show specific details throughout the scene? Even if you capture specific details, you still want to zoom out and show the overall scene to give context for those details.

Then you might want to reposition yourself in a different place to get a new angle on the subject and scene. Once again, look for a variety of shots. Look for a variety of action. Look for pieces of action that show something before a main action happens, the main action, and things happening after the main action.

Hollywood does something that is very useful for any person shooting video to think about. They break down the variety of shots into some very specific categories. They then think about shooting a scene using these types of shots throughout. That way they ensure that they have the variety needed. Here are those types of shots:

- **Wide shot (also called an establishing shot).** A wide shot gives a wide view of the subject and scene. Notice that this does not say a wide shot gives a wide-angle view. A wide shot is not about the focal length you are using. You could use a telephoto lens for a wide shot. A wide shot simply means you are framing up a wide area of the scene or around your subject. Because this wide area will tell you a lot about the setting of your subject, such a wide shot is often called an establishing shot. This establishes for the viewer something about the environment and place of your movie. Typically, a movie will have fewer wide shots than any other type of shot. (See Figure 4.17.)

- **Medium shot.** A medium shot comes when you get in closer to your subject, which can mean either physically moving closer or simply zooming in with your lens. The medium shot starts to de-emphasize the setting or

Figure 4.17

A wide shot shows a large scene that can establish the location of your movie.

environment around your subject and focuses more tightly on the subject. It is not a close-up so it does not emphasize the details of the subject, but more typically shows the whole subject. A medium shot will emphasize relationships within the shot such as between the subject and any other object, animate or inanimate. Depending on the movie, medium shots can be one of the most common shots you will take. (See Figure 4.18.)

- **Close shot or close-up.** A close shot or close-up is not the same as close-up photography. A close shot is referring to how you frame any subject. A close shot of a mountain, for example, is going to be very different than a close shot of a person or a close shot of a flower. Think of a close shot as a way of showing details of your subject. You are emphasizing specific parts of the subject by coming in close enough that you don't see the setting nor do you see relationships of the subject to other objects near it. You simply focus in on details. You usually will take a lot of close shots because you won't know which ones are going to work best until you start to edit your video. (See Figure 4.19.)

Figure 4.18
A medium shot focuses in on your subject and shows much less of the location.

Figure 4.19
A close shot features details of your subject.

■ **Extreme close shot.** An extreme close shot or close-up is a variation of the close shot. This shot simply goes in tighter and closer to the subject, focusing on just one detail of that subject and making it very dramatic because such detail is emphasized. (See Figure 4.20.)

Figure 4.20
An extreme close shot goes in tight to focus on a small detail of your subject.

You will sometimes see these four shot types listed as WS, MS, CS, and ECS. Keep them in mind as you shoot and this will help you get the variation you need for editing your video, whether that is a montage or a story.

Cutaways

Cutaways are unique to movies and are a bit different from the standard shot types just mentioned. They can be easy to forget if you are thinking about shooting as a photographer, yet they can be important to have when you are editing your video later.

A cutaway does exactly what it says, "cuts away" from the main action or scene. In other words, this is a shot that is not about the main action or subject. It is about things around the main action or subject, usually details that relate to that subject or the general scene, but are not part of it. Often, close shots are used for cutaways. So why would you want to use a cutaway?

■ **A bridge or transition.** When you are editing video, very often you end up with rather abrupt changes in the action. This can be awkward for a viewer. A cutaway allows you to include something in between those two clips so that there is a visual bridge or transition.

■ **A visual break.** A cutaway can break up video that is starting to look too similar. This visual break is like a pause to help the viewer stay interested in the visuals. (See Figure 4.21.)

Figure 4.21
Cutaways show things about a scene that do not include the main subject. They are used to bridge shots when editing.

- **Commentary on the subject.** Sometimes a cutaway can offer you the chance to add a visual that has more information about the subject or action that is going on. This can be a little detail that is important to the action or subject that can't be seen in shots that feature that action or subject. For example, if your hero must be at a certain place at a certain time, you can cut away to shots of a clock showing how close the impending deadline is. A classic example can be found in the many shots of the clock in the film "High Noon."

Special Shots for People

As you are recording people around you on video, it can help to think about some special shots that will help your video look better. These are shots that have a long history with Hollywood and anyone else who has produced movies of any kind. They're not just for the fictions of Hollywood, either, as they are also commonly used in news programs and documentaries.

The special shots allow you to define the scene in front of the camera to emphasize people and their actions. You don't have to use them all the time, but they are another set of ideas for you to use as you look for variety when shooting video.

- **Two-shot.** A two-shot is simply a composition of two people in the frame. This type of shot can be useful when you want to show some sort of interaction between the two people. A two-shot has a long tradition in movie making because it emphasizes just two people, which makes it easier for the viewer to follow. While you can shoot this at any angle, you will find that the interaction between the two people is best emphasized when they both occupy approximately equal space in the frame. (See Figure 4.22.)

Figure 4.22
A two-shot emphasizes two people fairly equally.

- **Over-the-shoulder shot.** Sometimes you want to shoot two people interacting, but you want to emphasize the person doing the talking. This is when you can shoot over the shoulder of the person listening, looking straight on to the person doing the talking. This is a very common approach used with news programs. Look at a show like *60 Minutes* and you will see the over-the-shoulder shot used a lot during interviews.

- **Group shot.** Groups are often a challenge when shooting video. The mix of people that go from side to side and front to back can be confusing to the camera, and therefore to the viewer. If you watch many Hollywood movies, you will often notice that group shots are set up very deliberately so that the group is more or less on one side of an imaginary line parallel to the camera and they are facing the camera, even if they are interacting with each other. This actually comes from the way groups are used in the theater. Sometimes this looks rather artificial. To get around this, moviemakers will often place some people closer to the camera but not facing the camera so that they provide a frame for the group.

While these ideas are traditionally used for recording people, they certainly can be used for shooting other things. You can think about using an over-the-shoulder shot, for example, when shooting animals or even inanimate objects.

Video Is a Moving Medium

It is important to look for movement when you're shooting video. That may seem obvious, but it is often overlooked when people first start shooting video. They are so used to shooting still photos that they don't look for movement except when the movement is obvious. Simply shooting a rather static image on video doesn't give you much beyond still photography. This gives you very little to work with when you are editing your video together.

There are two basic types of movement: movement of the subject and movement of the camera.

Movement of the Subject

Sports are a good subject matter for video because you always have the opportunity to capture movement. Even then, it is worth looking for movement that stands out. Just because something is moving in a scene does not necessarily mean it is going to catch a viewer's eye. You will sometimes see movement with your eyes, but the camera might emphasize the scene differently.

You cannot assume that the camera is capturing the movement that you see. It can definitely help to play back your video on your camera's LCD as you are learning to shoot video so that you get a better feel for how movement in a scene is actually translated to what the camera is capturing. That LCD may be much smaller than anywhere that you will be showing your final movie, but if you can see the movement on that LCD, people will definitely see it when it is bigger as well.

Movement is about speed as well as direction. Both of these affect what shows up in your video. Here are some things to consider about movement, but only regard these as thinking points, not a list of ways you have to shoot:

- **Movement from side to side.** One way that movement will occur in the video is when your subject moves from one side of the image to the other. This is a very distinctive movement. It is also the fastest way for a subject to move through your composition. Movement left to right follows the Western way of looking at things and so will be more comfortable for your audience to watch. Movement right to left might be less comfortable. Neither one is right or wrong, but each will have a different effect on your viewer.

- **Movement away from the camera.** When a subject moves from the near foreground to the background in a frame, you definitely get an impression of something leaving. This also uses the space of your scene in a very different way than simply using the space from side to side. This creates depth.

- **Movement toward the camera.** When a subject moves from somewhere in the background to the foreground, you definitely get an impression of that thing arriving. It can also be a dramatic way of providing a transition from a distant action to more active motion that's right in the viewer's face. Like movement front to back, this also creates depth. (See Figure 4.23.)

Figure 4.23
When a subject moves from the back of the scene toward the camera, that movement gains a three-dimensional feel as well as creating a dramatic composition for the viewer.

■ **Movement that is part of the character of the subject.** Many subjects have moving parts. This can be as simple as the leaves of a tree blowing in the wind or a woman idly tapping her fingers against a desktop. Look for subtle movement, then make sure you record that as you shoot video. You might shoot a beautiful landscape where there is not much action going on, but if you watch carefully, you'll notice the wind stirring the foreground bushes on occasion, and that can be enough movement to add some liveliness to the scene.

Movement of the Camera

One way to create movement in your video is to move the camera itself. This includes both physically changing the position of the camera as well as zooming your lens to create movement through the zoom. Camera movement can be very engaging for the viewer. However, if done wrong, it can also be disturbing and make video unwatchable.

Here are some methods you can use to create movement in your videos. Think about how you can use these movements to liven up your movie.

■ **Pan.** A pan is simply the swiveling of the camera on your tripod from left to right or right to left. Panning is a traditional way to reveal a wide scene such as a landscape or a big event. A pan, often from the left of the frame to the right, can also be used to follow action so that your moving subject stays within the frame of your composition. You should practice panning a couple of times before you record the video. Professional video shooters often practice their pans before shooting to determine where the pan begins and where it ends before starting. (See Figure 4.24.)

Figure 4.24 A pan is a shot that swivels the camera as it sweeps across the scene recording video.

- **Tilt.** A tilt could be described as a pan that moves up and down instead of left to right/right to left. A tilt can be used to show off a tall scene by moving your camera's view from bottom to top or top to bottom. As with the pan, it is important to practice this so you know where to begin your tilt and where to end it. A tilt that begins on someone's feet and ends on his face produces a much different effect than one that starts on a face and ends on feet.

- **Dolly.** A dolly is a wheeled cart-like camera support that moves over tracks as a scene is shot. A dolly shot typically moves across a scene from left to right or right to left. This gives a very different feeling than panning across a scene because as you move the camera across the scene and not just pan across the scene, both the subject and background change simultaneously, providing a very different feeling of movement. It is possible to hand-hold a camera and get similar results. To do that, shoot with a wide-angle focal length and an image-stabilized lens; then walk across the scene with the camera held in front of you. You can also use almost anything that has wheels on it to move you across the scene while shooting—skateboards, wheelchairs, shopping carts, and more.

- **Truck.** The term truck refers to a camera movement that involves the camera moving into or out of the scene. Sometimes this means that the camera is actually moving along with a subject as the subject moves through the scene. In Western movies, trucks were used to follow cowboys on horses as they moved through a landscape. A trucking shot is very different from using a zoom, which simply enlarges the image and background at the same time. When you're actually moving a camera through a scene with a truck shot, visual relationships of the background and everything else around the camera keep changing as the camera moves, and this can be a very interesting thing for video. Again, if you are shooting hand-held, use a wider-angle focal length and image stabilization if you can, then move into the scene as you shoot. (See Figure 4.25.)

Figure 4.25

A trucking shot involves physically moving the camera through the scene as video is recorded.

■ **Zoom.** A zoom is a flatter way of creating movement through a scene compared to a trucking shot. Most people understand what zooming is and the type of movement that occurs when you zoom while shooting video. You do have to have the kind of zoom that allows you to zoom during video without changing exposure. Zooms that have a fixed aperture will generally allow you to zoom while shooting. The reason for that is that the zoom simply enlarges whatever the camera is seeing; it does not actually move the camera through the scene to change spatial relationships. When doing zoom shots, it's useful to have a lens with a constant maximum aperture (that is, it is an f/4 lens from its shortest focal length to its longest). Variable aperture lenses (those that may start out at f/4 at their widest setting, but change to, say, f/5.6 when zoomed all the way in) must change exposure, and, potentially, depth-of-field as they are zoomed. Constant aperture lenses always retain their original aperture at any focal length.

No Seasickness

All of this movement can be a problem if you aren't careful. Too much movement can literally make your viewers get motion sickness when they're watching your video. Fast movement or continuous movement with a telephoto lens are the biggest culprits. A telephoto lens fixes what a person can see of the scene into a tight frame and when that locked view starts to move all over the place, it can be very uncomfortable for people who are susceptible to motion sickness.

The solution is simply to use motion carefully and deliberately. Use it for a purpose and not just because it's easy to walk around with your camera. And play back anything that you've recorded to be sure that it is not jerky or too bouncy. Bouncy, moving video can be especially disturbing for a viewer. (See Figure 4.26.)

Figure 4.26
A bouncing, unstable video image is difficult to watch and can even make viewers feel sick.

Jump Cuts

Imagine you are shooting some action. A young girl is jumping rope on the grass surrounded by beautiful flowers in a garden. You decide you've recorded enough of the girl jumping rope so you stop shooting. Now the girl goes away and comes back with a hula-hoop. You begin shooting again from the same camera position. Now imagine putting those two scenes together—the girl will be jumping rope and then all of a sudden she will be using the hula-hoop. This is called a jump cut. A jump cut can also come from when you cut a long scene into short pieces and the action does not match.

Jump cuts can be disturbing to an audience that is used to seeing things from one perspective on the screen and then is literally assaulted with a completely different perspective from a different angle and their mind's eye has to adjust to that. The way to avoid jump cuts is to shoot cutaways. Whenever you are shooting some action and then shoot the next shot of the same subject from a different angle, you're going to need something to bridge that jump cut. Look around for something that is related to the scene to allow you to make that change between action. Going back to our jump rope/hula-hoop example, this could be as simple as shooting some close-ups of flowers in the garden blowing in the wind. Viewers are used to seeing a transition like this that implies a change has been made.

Improving Your Movies with Better Framing and Composition

Still photographers tend to be very aware of composition. The methods you use for composing still photographs also apply to video. But there are some additional compositional and framing issues you must address when shooting video.

No Verticals

Video is a horizontal medium. All television sets are horizontal. Video is displayed on your computer horizontally. Photographers who are used to regularly shooting verticals will sometimes shoot a vertical for video. While you will occasionally see displays that are turned sideways for specialized use like marketing at a mall, that is not the usual use of video. So if you shoot vertically, you're going to be frustrated because you won't be able to edit it properly or use it for standard uses of a movie. The point is, always shoot your video horizontally unless you know there is a special use for a vertical video.

Use the Width—Avoid Centering Your Video

Video is shot with a 16:9 proportion. That is much wider proportionally than what you are used to with any still camera. Because it is so much wider, there will be more space on the sides of the subject. That space that can be very important to how you compose your video. You have probably heard that centering a subject or a horizon in a photograph is not a good idea. This becomes even more of a challenge with the extra width of the video image. (See Figure 4.27.)

Figure 4.27
Avoid centering your subject and you will create more interesting video.

Research has found that people find a centered image is less interesting to a viewer. When a viewer's eye movement is tracked across a photograph or other image, people tend to spend all their time in the center of an image when the subject is centered and don't visually explore much of the rest of the frame. They also quickly get tired of looking at such a static shot that has nowhere to "go."

In contrast, when eye movement is tracked across an un-centered picture, researchers find that people explore all portions of the image area, and absorb more than just the main subject. And they find the image more interesting.

The same thing is true with video. One thing that sometimes makes it a little easier to get things out of the center is to compose using your camera's LCD. When you're sighting through a viewfinder, there is a tendency to put the subject in the center of the frame. But when you are looking at the same frame on an LCD, it's easier to see the relationship of that subject to its surroundings in the rest of the space in the frame, and so to think about moving the subject out of the center.

The Rule of Thirds

The rule of thirds is based on dividing your image area into thirds horizontally and vertically. The two lines that separate the thirds horizontally are then used for strong horizon lines. This might mean that either one third of the picture is ground and two thirds of the picture is sky or two thirds of the picture is ground and one third of the picture is sky. The two lines that separate the vertical thirds can be used for strong vertical lines such as a dominant tree in the composition or a strong edge of a building.

These lines intersect at four points. Line up your subject on or near one of these points—lower left, upper left, upper right, or lower right. At any of these positions, the subject has a relationship to the rest of the image that is not equal on all sides. For example, when the subject is at the lower left, there is more space above and to the right of the subject than there is below and to the left. This spatial relationship can be very important for creating an appealing video composition. (See Figure 4.28.)

The rule of thirds might better be called a guideline of thirds, but that doesn't sound as interesting. It is true, however, that the rule of thirds should never be used as an absolute rule. These rules were originally designed for painters and other artists who create something from nothing. As a photographer and video shooter, you have to create a composition based on what is actually in front of the camera and you can't move things around the way a painter could. That may mean that the scene in front of you simply will not fit the rule of thirds.

Figure 4.28
The rule of thirds divides the image area into thirds horizontally and vertically. Where these lines intersect are good places to position a subject in the composition.

The point of all this is to get your subject out of the center. If the subject looks more dramatic by putting it closer to one side or another, getting it away from the traditional rule of thirds, do it. If the scene has a very strong visual element to it that is important to your video and it doesn't fit exactly any rule of thirds, then don't worry about it.

Changing Composition over Different Shots

A unique challenge that you will face when shooting video is that you will be lining up one shot after another, each shot having its own composition. When you are creating a slideshow, this is no big deal because the viewer sees each shot as its own unique composition. When you're creating video, the shots need to look like they go together, so two shots that have dramatically different compositions yet similar subjects can be confusing to a viewer.

This can be a problem if your subject bounces from one side of the image to the other between shots. While it is definitely important to work at getting your subject out of the middle, you need to be careful that your subject stays on the same side of the shots as long as you are showing a particular scene. If the scene changes or the subject moves from one side of the shot to the other, then you can easily show a new composition with the subject at that other side. But it is very distracting for a viewer to be watching a subject do something on one side of the screen, then in the next shot, the same subject is on the other side of the screen. If you aren't sure about which side you last used, try a shot that puts the subject on both sides if you can.

Balance

Balance in a composition relates to how one side of the image looks compared to the other. (See Figure 4.29.) When one side of the image is uncomfortably strong compared to the other side, the image is said to be out of balance, and it doesn't look right to the viewer.

So how do you get balance? If you put your subject dead center in the middle of the frame with identical things on both sides of it, you would have balance, even if the image were boring. Occasionally you will find an interesting scene that has a dramatic look from this sort of balance, but this is not common.

Usually you will look for balance that is not centered. One thing that the rule of thirds does is create a balance because of the way that the smaller space of one third on one side can balance the larger space of two thirds. This is actually a visual balance that we accept as long as the other third is not overly dramatic compared to the rest of the image. That would unbalance the scene.

You can also balance an image by simply looking at how something on one side of the frame relates visually to something on the other side of the frame. This does not need to be two opposite objects or two people or anything like that. This is also about using the image area fully so that every part of it from left to right belongs in the composition. You can balance something on one side of the frame with space on the other. But that space has to be open and with only minimal detail so that it is clearly seen as space by the viewer. If space on one side of the image is filled with a lot of detail, there will not be a balance.

You can also balance something small and something big. Visually it is interesting to see that something small can balance something big, but there needs to be a distinct difference in size in order for this to happen.

Figure 4.29

Balance relates to how one side of the image balances the other visually. More interesting compositions come when this balance is not simply a repetition of one side to the other.

Working with Foregrounds and Backgrounds

How you work with your foreground and background has a strong influence on the composition of your video image. Foregrounds and backgrounds are important to any visual medium, but they can be especially important for video because you often have movement that's happening in the space between the foreground and background or going from the foreground to the background (or vice versa). (See Figure 4.30.)

Foregrounds are especially important when you are working with a wide-angle focal length. The narrow horizontal format of video captures less foreground than standard still photos, but a wide-angle lens will still tend to emphasize the foreground. So often, photographers will use a wide-angle to pick up a lot of a scene from left to right but they don't see the entire extra foreground. That extra foreground can be especially noticeable when the camera is moving. Even a simple pan or tilt will tend to over-emphasize the foreground because the foreground will move in a larger distance related to the camera position as compared to the background. This is why it is so important to pay attention to what is in your foreground when you're shooting with a wide-angle lens.

Foregrounds can also be important when you are shooting with a telephoto. Often, photographers don't think about the foreground with a telephoto because the telephoto allows them to zero in on the subject without a foreground. However, having something in the foreground to shoot through can add an interesting frame to the scene, especially if things are moving within that scene. A foreground object for a telephoto does not need to be sharp as long as the subject is sharp.

Backgrounds are always important for any type of photography and video. An interesting way to work with the background is to create a foreground-to-background relationship in your composition. Find something in the foreground

Figure 4.30
A foreground-to-background relationship can be an effective way to compose a video shot.

that relates to the background in some way. This can be as simple as a dark object along the edge of your image area that acts as a frame for the background.

Another way to work a scene from foreground to background is to look for the depth of the scene. Find something in the foreground that is prominent and interesting and then look for visual elements that lead the eye to the background. This can be interesting when you have movement that is going from foreground to background. This can also be very interesting when you have something moving in the foreground that relates to a background setting.

Background movement in video can be a special challenge if it distracts from your intended subject. If you are shooting a still photo, you don't care if something is moving in the background because it will be stopped for the photo. But with video, such movement can be a distraction even if the background is out of focus. It can keep your shot from being the best it can be. This means that you have to be aware of all movement in the frame. (See Figure 4.31.)

Figure 4.31
Watch for unwanted movement in the background of your shot that could distract from your subject.

Chapter 5

Making the Most of Lighting

Light is so obviously critical to photography that it is almost a cliché to say it. Yet, light is something that is often overlooked when photographers focus too much on a subject. Light is also critical for good video and presents some special challenges for shooting video as well.

People See Differently Than the Camera Sees

A big challenge that everyone faces with photography and video is that your eyes and the camera sensor see the world very differently. People tend to see subjects; the camera tends to see and over emphasize light and shadow. That can be a problem because the light can then dominate a picture and make it hard for viewers to really see the subject in the movie as they saw it in real life.

Light can show off your subject and make it look better, but it can also obscure your subject. So what can you do to get good lighting on your subject? Here are some ideas.

- **Look for the light.** Instead of simply looking for the subject, look for the light and its effects. Where is the light and what is it doing? Where are the shadows and are they masking detail, or creating a distinctive look; are they helping or hurting your subject? (See Figure 5.1.)
- **Use your LCD as a way to see the light, not simply as a sighting device.** If your subject is easy to see on that small LCD monitor, then the light is probably helping. If the light mainly shows you light and shadow, and the subject is not so easy to see, then the light is a problem.
- **Just say no!** You have a lot of choices to make when photographing or shooting video. You choose things like shutter speed, f/stop, focal length, and so on. But something that many photographers don't think about is just choosing not to shoot a particular image at all because the light is not helping the subject or the scene. When you realize you can say no to a shot, this opens you up to finding the right shot that you can say yes to.

Figure 5.1

Learn to look at the light as well as the subject when you are preparing to shoot.

It can also be helpful to recognize what a camera can and cannot do in different light. As you shoot more video, you'll see that a camera cannot always capture the scene in a way that enhances the video. Here are some ideas to help you think about the limitations when shooting video in different types of light.

- **High contrast light is tough.** Cameras do not do well with high contrast light, and this is especially true with video. Your eyes can see dark shadows and bright sunlit areas at the same time, but the camera cannot.

- **Low contrast light can be good.** Video handles color and tonality in a different way compared to still photography, even though it is all coming from the same sensor. Video does well with low contrast light, especially on people. (See Figure 5.2.)

- **Big bright areas are a problem.** Your eye tends to be attracted to bright areas in an image, even if that area is not located near the subject, where you really want attention focused. They are especially a problem when you are working with video. Bright areas will not record properly and will create a very distracting blob in your scene. (See Figure 5.3.)

Figure 5.2

Low contrast light can be good for many video subjects, especially people.

Figure 5.3

Watch out for bright areas in the background of your subject that can fight with the rest of the scene. Notice how this bright sky dominates the image.

■ **Backlight can be good or bad.** Backlight, when the light is coming from behind your subject and toward the camera, has the potential of being either effective as a way of highlighting your subject or distracting. Backlight is very often used in the movie business because it helps separate the subject from the background. However, when backlight is used in such situations, there is usually also a very strong front light on the subject to help balance the backlight. A pure backlight without that strong front light can really be a problem with video because of the high contrast. You could use a flash to fill in the shadows for still photography, but you can't do that with video. Sometimes a reflector can help.

■ **Watch out for a small spot of light in a large area of darkness.** This can be a very dramatic way of using light, as you will notice any time you go to the theater. But it also creates a very harsh light that the camera cannot fully deal with. With even a slight wrong exposure, the bright light will be washed out and the dark area will still be too dark. The best way to deal with such light is to meter your subject carefully and expose for the bright light and forget about the dark areas because the camera cannot handle both.

■ **Be careful of very bright subjects such as snow or sand.** Your camera will want to underexpose very bright subjects because it thinks they are a very bright light. It doesn't know the difference between a bright subject and a bright light. When you're shooting still photos, this can be corrected in the computer with Photoshop or Lightroom. Remember that your adjustment options are limited with video, however, so having a too-dark image from these conditions can be a problem. The best thing to do is give enough exposure so that bright subjects look bright and not dark gray in your LCD.

Continuity and Light

Continuity simply means that as a viewer watches the shots making up a scene unfolding in front of him or her, the scenes have a consistency about them so that there are no abrupt changes in perspective, viewpoint, content, or lighting that make no sense. The classic example of this is in a Hollywood film where a hat keeps appearing and disappearing from an actor's head as the scene goes on. Another example of this would be a glass in front of an actor that keeps changing from being full to empty.

You're probably not going to have to worry too much about this type of continuity. In the last chapter, you learned how composition can cause a continuity problem for the viewer when a subject changes abruptly from one side of the frame to the other from shot to shot. Another type of continuity that is a challenge for everyone is light. When light changes dramatically from shot to shot, this change can be hard for a viewer to follow. The viewer starts paying too much attention to the change in the light, because light is such a visible part of the image, rather than seeing the changes that are actually important to the movie.

So one thing to think about is keeping your light or lighting consistent for a particular group of shots. For example, it can be very disturbing for a viewer to watch video of a person who is in the sun for one shot, and then is in the shade for the next, and then is back in the sun for the shot after that without having seen the person move from place to place. Another example of this would be if you are shooting indoors and have added some light, and that supplementary light kept changing from shot to shot. Earlier in this book, you also learned about how important it is to choose a specific white balance. That also affects continuity of light. Illumination should be the same "color" from one shot to the next.

You don't have to be shooting some fancy Hollywood style movie for this to be important. You could be simply shooting a series of images for a nice montage to music. But once again, if the image is abruptly changing in the type of light that is appearing in the shot, the viewer will find that very distracting.

The point is that it can be very helpful to be aware of the light on your subject as you are shooting. Try to look for consistency of light when you are shooting a series of images that are meant to go together. While natural light will often change quickly, such as on a partly cloudy day where it goes from sunlight to cloud light, being aware that there is such a thing as continuity of light will help you get shots that are more likely to work together when you go to edit them. (See Figures 5.4 and 5.5.)

Figure 5.4 Figure 5.5 Watch out for bright areas in the background of your subject that can fight with the rest of the scene. Notice how this bright sky dominates the image. Also, be aware of big changes in light on your subject.

Shooting in the Sun

There are many great subjects for video that you will be shooting in sunlight. This will range from soccer games to flowers to landscapes and more. Sunlight can provide great light that defines your subject well for video, but it can also create very harsh light that makes your video hard to watch. Here are some ideas to keep in mind when shooting video in sunlight:

- **Early and late light.** Some of the best times for shooting video on a sunny day are early and late in the day. This is especially true when you're shooting a big scene such as a landscape or a cityscape. Early and late light is a low light that gives good dimension and great shadows for your scene. It will also often have a nice warmth to it.

- **Midday light.** Midday sunlight is probably one of the most difficult lights to deal with when shooting video. Bright sunlight tends to be a rather harsh form of illumination, with shadows often located in rather unattractive places. This can be especially true when shooting people. We tend to focus on the eyes of human subjects, and a broad hat worn with the sun overhead can produce an inky shadow that hides the eyes or most of the face. Even just a slight cloud cover will soften this light, perhaps eliminate a need for a hat in the first place, and make it easier to shoot for video. Avoid having much sky in the image during midday conditions because it will create large bright areas that will distract from your subject. (See Figure 5.6.)

- **Dimensional light.** A dimensional light gives your subject shape and form. Professionals use light to create dimension all the time; they know that this makes subjects look more attractive in the two-dimensional form of photography and video. Dimensional light is often a low light that hits

the subject from the side. Side lighting gives the subject dimension because part of the subject is in the light and part in shadow, and that combination gives us the impression of three-dimensional form. You do have to be careful to expose for the bright light, never for the shadows. (See Figure 5.7.)

■ **Backlight.** As mentioned above, backlight can be challenging because of its harshness. However, backlight can also be very effective when it outlines a subject and helps it stand out from the background. You have to be willing to accept that backlight will very often mean you cannot hold detail in both the bright and dark areas at the same time. With video, this may mean that you have to expose for the bright areas and let the dark areas be dark.

■ **Shadows.** Sunlight definitely creates shadows in your images. Shadows can both help or hurt your image. Look for shadows. You may find some interesting subject matter in just the shadows, even when shooting video. It can be very interesting, for example, to shoot moving shadows as a part of the sequence for video. Watch out for shadows that crisscross your subject in ways that break up the subject and make it hard to see.

■ **Light and the background.** Sometimes it is easy to be so focused on your subject that you don't see what is happening in the background. Bright sunlight creates light and shadow not only on your subject, but also on the background. When you have a lot of light and shadow chopping up your background, you can find that the background becomes very distracting and takes away from your subject. Watch out for the light and shadow not just on your subject, but also on the background behind your subject.

Figure 5.6
Bright sun and backlight can create harsh light that can be difficult for video to handle.

Figure 5.7
Early and late light can be very attractive and dimensional for large scenes.

Shooting in the Shade

When you shoot in the shade, you are shooting in the shadows, so dramatic shadows are taken out of the picture, so to speak. That does not mean that you won't see slight shadows in the shade. But in the shade, light is mellow and gentle—a very good light for video. Here are some thoughts that will help you shoot video in the shade:

■ **Soft, dimensional light.** A soft light with dimension is actually quite important when you are shooting video. The soft, gentle light means you have no harsh light and shadow contrast to deal with. But shade often has a brighter light coming from one direction, whether that is light from the sky, light bouncing off of a big cloud, light bouncing off of a wall of a nearby building, light bouncing off the wall of the canyon, and so forth. This provides a dimensional light that adds some richness and dimension to your scene. (See Figure 5.8.)

Figure 5.8
Shade provides a gentle, soft light for subjects.

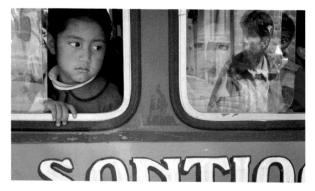

Figure 5.9
Shade can be a very attractive light for people.

- **Move your subject to the shade.** When the light is harsh, especially when you are recording people, move your subject into the shade. That will get rid of that harsh light, plus it will let them interact with the camera without squinting or being uncomfortable from the harsh light. (See Figure 5.9.)

- **Set your white balance.** When you're in the shade, usually you will often prefer to set your white balance to Shade rather than rely on auto white balance. This is very important because shade can be very blue in tone, because the illumination comes indirectly from the blue sky that is often above shaded areas, rather than from the sun. That blue light can wreak havoc with skin tone and make people look rather deathly instead of warm and friendly. Shooting with a white balance set to Shade will minimize your problems with that blue cast. As discussed below, sometimes the shade will not have the blue cast because of light reflecting into the shade from something other than blue sky. Then you may have to use a different white balance.

- **Watch for natural reflectors.** Much of the time shade is illuminated from the blue sky. But sometimes light comes from other reflectors such as a big white cloud that floats over the scene and reflects a beautiful light on your subject, or a nearby wall reflects the light into the shade for an attractive, open light on your subject.

Shooting When It Is Cloudy

Any clouds over the sun immediately change the quality of the light. The light becomes softer and more gentle. Harsh contrast starts to disappear. But clouds are quite different. Light clouds that barely obscure the sun will give a very different light than the heavy clouds that appear before a storm. To get the best

out of cloudy conditions, it is helpful to know the difference between the types of clouds and what you might do:

- **Light clouds.** When you can still see the sun behind the clouds, these are light clouds. These clouds diffuse the light of the sun and make it gentler on your subject. The sun is still strong enough to cast some shadows, which adds dimension to the subject without being harsh. This can be a really beautiful light for shooting video.

- **Medium clouds.** When the clouds get heavier and you can no longer see the sun, those are medium clouds. Medium clouds diffuse the light of the sun more than light clouds and make the entire sky the light source. The result is that there are very few shadows and everything is fairly evenly lit from above. This can bestow a very open look to your subject because there are no strong shadows. Be careful to not underexpose your video shot in these conditions, which can make the image look heavy and less attractive. (See Figure 5.10.)

- **Heavy clouds.** Heavy clouds that look like they are filled with rain and fog can be a problem for any type of photography. There is a heaviness of the light that is often translated to the image and is generally not very attractive. Underexposure can make this even worse. (See Figure 5.11.)

- **Set your white balance.** Just like with shade, it is important to match your conditions with the white balance setting. Using the Cloudy white balance option will keep the image from being too cool in color. Cloudy conditions often look their best with at least a little bit of warmth to the image, which will come with the right white balance setting.

- **Add a light.** When the light conditions get really dark, it can be helpful to actually add a light. You can't add a flash with video, but you can get portable LED lights that can be used to brighten up a scene under heavy clouds.

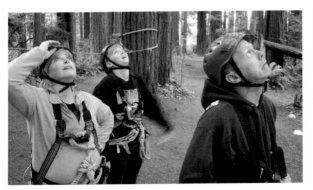

Figure 5.10
Clouds and shade in the woods can soften the sun so that there are no harsh shadows anywhere.

Figure 5.11
Cloudy conditions and fog can give off a soft, enveloping light.

Shooting in Low Light

Low light conditions, such as shooting at twilight or indoors at night, used to be a big problem for traditional video camcorders. Under those conditions, you almost always had to add light because the cameras would produce noisy and unattractive images otherwise. Two things have changed this for shooting video with a dSLR. First is that noise reduction capabilities built into cameras today are very, very good. Second, the sensor size of a dSLR is considerably bigger than the sensor size of a traditional camcorder. Larger sensors allow manufacturers to do more to control noise. In addition, the latest sensor technologies allow you to use the higher ISO settings without picking up excessive noise. Now you can shoot at low light levels with the existing light and do quite well with a dSLR. (See Figure 5.12.) White balance has a big influence in shooting under low light conditions but you don't choose an appropriate white balance in the same way that you do when you shoot during the day.

Figure 5.12
Low light shooting is possible with video today.

Here are some things to consider for white balance and general shooting in low light conditions:

- **Tungsten white balance.** If most of the light that you are dealing with is an incandescent light, then you can choose a tungsten white balance. This generally will give a very neutral look to the scene, although the color of different tungsten lights does vary, so this will vary as well. Sometimes a neutral look is exactly what you want.

- **Fluorescent white balance.** If conditions include mostly fluorescent lights, then use a florescent white balance. This will produce a fairly neutral look, although again, fluorescent lights are quite variable and you will see some differences in color.

- **Daylight white balance.** We have an expectation that artificial light will have somewhat of a warm feel to it. Using white balance to adjust for that warmth and make interior lights look purely neutral is not always the best. Using Daylight white balance can actually give a very warm and interesting look. (See Figure 5.13.)

- **Twilight conditions.** When the sun has set, you can get some very interesting light. The light level will be very low and you will need to set your ISO to a high setting, but this can give a unique look that you can't produce in any other way. You will probably find that a warmer white balance setting actually looks best, and since the auto white balance setting of most cameras may overcompensate, you might want to try Daylight or even Cloudy settings and see what the results look like.

Figure 5.13

Sometimes a warm white balance works well for low light conditions such as this twilight city scene.

Creating Your Own Lighting

When the light gets low or you are shooting indoors, you may need to create your own lighting. An entire book could be written about lighting. This book is meant to give you a quick and easy field guide to shooting video with your camera, so here you will learn some quick and easy ways of dealing with light when you are controlling it. A key to working with your own lights is to remember all of the things that have been discussed in this chapter, especially about light and shadow. Look at how the light is affecting your subject, not simply that the light is making it brighter.

Sunny conditions are very similar to direct lighting, when you point a light straight at a subject without changing the light in any way. Keep in mind the same ideas offered above for sunlight apply when you are using a light directly. (See Figure 5.14.) Bounce and diffused light sources are like cloudy days; you can use ideas from that section to help you with them. And here are some ways to create your own lighting for video (the next section will include information on specific types of lights):

- **Bounce light.** One of the easiest ways to create a nice light for video is to take a bright light source and point it at a white ceiling or wall. You can also point it at anything white, from a bed sheet to a piece of foam core art board. This results in a nice overall light that is gentle without harsh shadows. Where you put the light will affect where shadows fall. If you need a lot of light over an area, you can place multiple lights and point them at the ceiling. Because the shadows are soft, you will not have a problem with overlapping shadows that could be distracting. (See Figure 5.15.)

Figure 5.14

A direct light can be a dramatic light for the right subject. It definitely produces shadows.

Figure 5.15
Bounce light is an easy light to use because it is gentle with very soft shadows.

- **One light plus a reflector.** A quick way to create a dramatic lighting scene is to point your light source directly at your subject and then place a reflector on the opposite side of your subject. The reflector fills in the shadows and makes them less harsh. The direct light from your light source will give hard edges to the shadows, which is dramatic, but can be unattractive on some subjects.

- **One light with a diffuser.** You can soften any light by placing a diffuser a slight distance in front of it. A simple way to do this is to use a white, translucent umbrella. Many lights that can be used for video will include a mount for the umbrella's stem, and photo umbrellas are relatively inexpensive. With one light and a diffuser, you get a very gentle light with soft shadows that are controlled by where you put this light in relation to the subject. (See Figure 5.16.)

Figure 5.16
Put a diffuser in front of the light and shadows lose their hard edges. Such a light is great for people.

- **One light with a diffuser and a reflector.** Add a reflector to the opposite side of your subject from the diffused light source, and you will get a very open light that works quite well with video. There still will be a shadow to add some dimension to the image, but you won't have any harsh contrast between the bright and dark areas.

- **Add a background light.** As you are lighting your subject, you will notice that the background will not be getting the same light. That can be very dramatic if appropriate, but sometimes you want to have some detail in the background. The easiest way to do that is to simply take a second light and point it at the background. This light can be pointed directly at the background or you can use a diffuser to soften it. (See Figure 5.17 for examples of the same subject shot with different background illumination.)

- **Add a hair or detail light.** When you're recording people with video, it often helps to have a backlight on their hair. This helps separate them from the background and can create a little sparkle in their hair. To do this, you simply need a third light positioned behind the subject and pointed at their back.

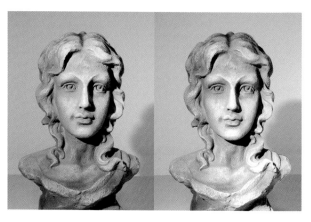

Figure 5.17
A second light on the background can change its color.

Lights and Lighting Gear

To get started adding some light to your subject when you're shooting video, you don't have to spend a lot of money. As you just read, you can do well with just one or two lights. (See Figure 5.18.) Some professionals have made a career of certain types of shooting without incorporating a lot of lights. Having fewer lights makes things much simpler and easier for you. As soon as you add more lights, things get more complicated and can take a lot more time to set up and use.

Figure 5.18
An LED light source being used for a direct, dramatic light on the subject.

The actual lights that are used for lighting are sometimes called lighting instruments. That simply means a light source that you are using to create light for your video. All lights used for video must be continuous light sources. You cannot use flash for video because it is not a continuous light source.

Here are some common and readily accessible types of lights that you can use for video:

- **Quartz lights.** Quartz lights are one of the most popular types of lights for video. They are relatively inexpensive and give off a steady light with a constant color. Quartz lights have a color that is a type of tungsten light and generally balance quite well to Tungsten white balance. You can get a quartz work light that can be used for video from a place like Home Depot, or you can get more elegant quartz lights that are designed specifically for photography and video. Be careful though; quartz lights can get quite hot when in use. Grabbing one that's been on for a while can cause a serious burn, plus they can heat up your subject. Never put something that could burn right next to them. (See Figure 5.19.)

- **Fluorescent lights.** There are fluorescent lights that are made specifically for video and film production. These lights can be quite expensive. However, since video shot with a dSLR can have its white balance adjusted for any light, you can get relatively inexpensive fluorescent lighting fixtures from most hardware stores that can be used for video lighting. Fluorescent lights don't get as hot as quartz light, or use as much power, but you'll lose some of the brightness. You may not have enough light from them to use them with a diffuser, although fluorescent lights tend to be a wider and softer light source than a quartz light, so you might not need one.

Figure 5.19
A quartz light in use.

- **LED lights.** A newcomer to video production is the LED light. These have become very popular with many professional video production companies because they don't use a lot of power and they do not get hot. They are more expensive than quartz lights and have less power, but for many video people, the fact that they operate without heat is a big benefit. You can also try out LED work lights from your local hardware store. Like fluorescent lights, LED lights might not have enough power for you to diffuse them and still get enough light, but they'll also often come in wider configurations so they start with a little softer light than a quartz light. (See Figure 5.20.)

Once you get lights, you'll need something to hold them, and you may need some additional accessories. If you get a work light from your local hardware store, that light might come with some sort of a stand. Photo light stands are much more elegant and attractive than the stands you'll get for a work light. They are designed to work efficiently with lights for photography or video and look like they belong in a photo or video shoot. Here are three different types of accessories that you may find very helpful for lighting.

Figure 5.20
An LED light in use.

- **Light stands.** Light stands have a center column that allows you to position the light higher or lower. They also have folding legs that allow the whole unit to collapse into a very small and lightweight package. You want to get one that is sturdy enough to hold whatever light that you are using because lights also come in different sizes and weights. Black light stands can be very helpful because they don't reflect shiny highlights on to subjects that have reflective surfaces.

- **Reflectors.** A reflector is something that you will constantly use for video. You can get started very easily by going to an art supply store and purchasing a white foam core art board. This can then be clamped to a light stand using a utility clamp that you can get from a hardware store. You can also buy folding reflectors that are designed for photography and video. These are typically circular reflectors that come in a variety of sizes. Small reflectors work well for small subjects; large reflectors work well for big subjects. You can get reflectors in a variety of surfaces as well: white for a very nice diffuse reflective light, silver for a stronger reflected light, and gold for a warmer reflected light. Reflectors can be used outdoors as well as indoors to help control your shadows. To use a reflector, simply place it on the side of your subject away from the main light and then move it around until

you see the best reflected light on your subject. You could also bounce light into a reflector that is placed anywhere to create a softer, more gentle light from the original light source.

■ **Diffusers.** These are simply anything placed between the light source and your subject that softens and spreads out the light. Diffusers work best when they are not directly on the light. Hang a translucent shower curtain or transparent tracing paper in front of your light to defuse it to try this out. Remember, never put flammable diffusers directly on or too close to a quartz light. The easiest diffuser to use for this purpose is a shoot-through translucent white umbrella because it does not need a lot of fancy attachment gear.

Chapter 6

Editing Your Movie

Entire books have been written about editing video. This is a book about using your camera in the field to shoot video, so this won't be everything you ever wanted to know about editing your video. However, video editing is so important that you need to start thinking about it even as you're shooting. You may have noticed in other chapters that some of the things that you shoot affect what you can and cannot edit in your final movie.

For the best results with your movie, you can't treat video like still photography where you can sort through your pictures and put together a slideshow later. Video requires you to have certain types of shots already in hand so that they will fit together nicely, logically, and artistically, and create the video that you're going to be proud of. This does not mean that you're going to have to do a lot of extra work. In fact, knowing a little bit about video editing will help you shoot more efficiently and get better results from your video because you've shot what you need from the start. (See Figure 6.1.)

In this chapter, you'll learn a little bit about the basics of video editing in terms of how it works. This will give you an understanding of what you will need when you are shooting video.

Figure 6.1 Your movie will be edited from individual shots to create sequences of clips that come together for the final movie.

The Basics

Video editing is based on putting distinct clips together in some sort of order. Each individual segment of video, whether that is based on how you captured individual shots or based on splitting up individual shots, will be put into an order from beginning to end. Video is a linear medium, meaning that it is viewed one segment after another in a linear fashion.

Some people like to edit video by taking all of the clips that they've shot and putting them into an order before doing any trimming or editing of the individual clips. Some editing software such as Adobe Premiere Elements offer a "sceneline" as part of the interface that essentially encourages you to put together a series of clips in some sort of story or other order simply based on the overall scenes of the clips.

Since you obviously need some sort of order to your video anyway, this way of putting clips together quickly gives you an overview of how the clips are looking as you go from one to another. Once they are put together, then you can go in and start adjusting the individual clips. You can shorten clips to make them better fit a particular sequence, decide exactly where a clip will begin or end so that it better works with a clip before or after it, and so forth.

Other people like to edit video by looking at clips one at a time and putting them together on a timeline. Most video-editing software does offer some sort of a timeline that shows you how the clips are ordered and their length. At some point, even if you are simply looking at putting all of your clips together and then doing the specific edits on each clip, you will still use a timeline when you do those specific edits. (See Figure 6.2.)

People who edit video clips one at a time will trim each clip as they go so that the unneeded beginning and unwanted endings are removed before the clip is actually put onto the timeline. The advantage of this way of editing is that you can start to build sequences of clips quite quickly because you are seeing the sequences right away. (See Figure 6.3.)

Figure 6.2 One way editing is done is to put together a whole group of clips at once onto a sceneline.

Figure 6.3 Another way to edit video is to trim each clip as you add it to a timeline.

None of this is permanent. No matter how you organize your clips or how you start editing the individual clips for length as well as their in and out points (which are where they begin and where they end), you can change any of this at any time. Your editing software will also separate tracks for audio and video so you can deal with them separately if needed.

But being able to change your movie at any time is not always a benefit. That can mean that you are constantly revising and constantly changing the order or organization of your clips and their sequences. By thinking about how you shoot your video ahead of time, you will start to have an idea of how you're going to put these sequences together when you do edit them. You can then shoot specific shots that will go into these sequences. That can make things a lot easier when you are editing.

Putting Sequences Together

In Chapter 4, you learned about the different types of shots that you can use while shooting your video. You also started thinking about how certain shots might go together and about looking for beginning, middle, and end shots.

Now when you go to edit your clips into sequences, you have to consider how individual shots go together and work with a complete group of shots. Here are some ideas to think about for editing video:

■ **Think beginning, middle, and end.** Even when you're looking at sequences within your movie, think about what clip can go first, what clip can go last, and what clip might be in the middle.

■ **Edit to continually build story.** Your overall movie can have a story with a beginning, middle, and end as you have seen elsewhere in this book. You can also look at your sequences as a way to gradually build that story and each sequence has its own mini story that is built from beginning to end. (See Figure 6.4.)

Figure 6.4 You can edit sequences to build story by showing your subject from a distance then moving in close.

■ **Look for natural transitions.** A transition between a wide shot and a close-up might simply be a medium shot. A transition from one person to another person might be a close shot of a handshake. A transition from one part of the city in a travel movie to another part of the city might be a shot from inside a cab as it drives down the street.

■ **Look for movement.** Because movement is so important to video, you can often use movement to help you transition between clips within a sequence. If you look for movement that starts in one clip and then finishes in some way in another part of the sequence, you have something that most people find very comfortable when watching video.

■ **Look for directional movement.** One way of helping sequences work together is to find movement that is going in a consistent direction. If a moving object starts going to the left and then in the next clip is going to the right, then in the following clip it is going front to back, that can be very confusing. By looking for movement that consistently is going from one part of the frame to another or gradually changes direction, you help the viewer understand the video much better. (See Figure 6.5.)

Figure 6.5 Direction of movement within the video composition can give you guidance on putting together a sequence.

- **Look for color transitions.** This is a classic way of creating a transition with visuals and has been used for slide shows as well. When you have a sequence of images that have some strong colors, it can be very helpful to keep colors together or at least have colors gradually change as you go through a sequence. That is less abrupt to a viewer.

- **Look for continuity of subject.** An effective way of putting together a sequence of clips is to keep focused on a particular subject and follow that subject through each sequence. Each sequence shows something new and fresh about that subject and your total group of sequences brings all of these ideas together to give an overall impression about the subject through the movie. This can be challenging if you have not shot enough variety of your subject. That is where it can be helpful to use a cutaway to cover awkward changes of the subject from one clip to another. (See Figure 6.6.)

- **Edit to reveal a subject.** You might start out a sequence with wide shots or shots that are related to the subject yet don't show the subject in full detail yet. Over the sequence of clips, you gradually reveal the subject until the last shot shows the subject in its full glory.

Figure 6.6 You can follow a specific subject through a sequence to help you edit your video.

Working with Audio

The audio in your movie is extremely important. Good sound can make your presentation more effective. Viewers base some of their expectations of what they see from what they hear.

As you are putting your video together, it is important to pay attention to what is happening to the audio. Sometimes when you put two clips together, the audio just does not go together at all. That can make the editing seem both obvious and ugly.

Here are some ideas on how you can tidy up audio as you edit your video. Music is an option, and it is covered in the next section.

- **Get rid of bad audio.** If you have bad audio on a clip, don't use it. Most video-editing software will allow you to remove the sound from a clip.

- **Use audio from another clip.** Not only can you remove audio from a clip, you can also remove video from a clip and just have the audio. This way you can fix problems from one clip by incorporating audio from another clip. This is also a good reason to sometimes shoot a scene for audio you can use later.

- **Change how loud the audio is (i.e., the audio levels).** No matter what you do, you can have audio that is distinctly louder or softer as you go from one clip to another in a sequence. In your video software, adjust the levels of the audio clip by clip when needed.

- **Fade audio in, fade audio out.** Sometimes audio can start and end abruptly as you go from clip to clip. To remedy this, fade the audio in and fade it out. That makes the transition less abrupt. Many video-editing software programs include a fade in and fade out command for audio clips.

- **Overlap your audio.** While this is a little bit more sophisticated, it can be very helpful in getting your clips to flow together better. A very simple way of overlapping audio is to find a clip that has good audio that fits the sequence. Remove the video and just use that audio to overlap your edit points. Fade your audio in and out and you will often have a very nice transition between clips. As you learn to edit your video, you will also discover that you can extend audio from one clip so that it overlaps the edit point and begins while the other clip is still showing video.

Using Music

Music can be a wonderful way to tie clips together in a sequence or even use throughout the entire movie. But you should not select music simply because you like it. Be sure that the music goes with the video. A series of flowing, gently moving clips of nature is probably not going to work with some modern hip-hop type of music. On the other hand, as much as you might like chamber music, it might not go that well with a kid's birthday party. That may sound obvious, but very often people put together inappropriate music with video resulting in an awkward experience. (See Figure 6.7.)

When the folks in Hollywood are putting together a movie, they put a great deal of thought into exactly what music will be used. You don't have to go to

Figure 6.7 Imagine this scene on the Thames River in London with music from a Bond movie. Then think about it with a light classical music like something from Handel. Finally, think about a Beatles song with the scene. Each theme will create a different impression of the visual.

that extreme, but simply knowing that the impact of your video is going to be affected by the music that you are playing with it is really important.

Be careful of using music that contains lyrics. While lyrics can be effective and provide a counterpoint to the visuals, very often they are a distraction. The reason for this is that the viewer starts listening to the words and comparing it to what they see in the movie.

A very big caution about music: be careful about using copyrighted music for any video that is played in any commercial setting. Even if you are creating a free video, if there is a cost for getting into the location (including for educational purposes when there is a charge) or the video is done for any marketing or business purposes, you can be sued by the music industry if you don't have permission to use that music.

If you think that you are unlikely to be caught, think again. The music industry has consistently gone after individuals just to make a point. They have no qualms about big dollar amounts in their suits either.

If your movie is purely for personal use or educational purposes where no money changes hands, then generally you are okay with any music you select. However, there is free music available on the Internet that can be used for many purposes without much in the way of restrictions. And if you're using video for any business purposes, you will find that there is a lot of inexpensive

music available on the Internet that can be purchased for low fees and used without paying additional royalties to the supplier.

Apple's Garage Band and Sonic Desktop's SmartSound software allow you to compose music to a specific duration to match your editing needs for particular sequences. This can be really helpful as you are putting together a sequence of clips so that the music starts and ends when your sequence does. In addition, this music is available for commercial use.

Video-Editing Software

To edit video on your computer, you do need some software. You also need a computer that is capable of handling the video. Video puts a big stress on a computer system. You are working with 30 individual images per second of video. With high-definition video, that means 30 one- or two-megapixel images for each of those seconds—that's a lot of data for a computer to process. The processors of most modern computers will be able to handle this, but an older computer will struggle.

When a computer cannot keep up with the video, the video might not play smoothly and you may have problems with audio. This does not mean there is anything wrong with your video, and it does not mean you cannot edit your video and get a final version that plays fine. It simply means the computer is struggling with the original high-definition video files. Your final edited version will be fine.

Older software can also have trouble processing HD video from dSLR cameras. This is because the cameras compress the video so that the computer plus software has to deal with decompressing 30 frames per second and displaying them as video, too. Usually you can do something called "rendering" the video to allow the program to convert the video from its original format into a new format it can handle more easily as you edit.

You will need enough RAM and a fast hard drive. Enough RAM generally means at least 2GB, but it's better to have more. If you craft a lot of video, you really should have a dedicated hard drive specifically for video. You may find that you need a hard drive that has 7200 rpm for speed and connects to the computer with USB 3.0, SATA, or FireWire. You need the fast connection because a fast hard drive does you no good if it can't get the video files to the computer's processor fast enough.

Video-editing software is available from a number of companies. The two best known companies for this software are Adobe and Apple. They offer both inexpensive, easy-to-use software and more expensive professional-level video

programs. Here is a short overview of the programs. You can learn more at the respective websites.

■ **Adobe Premiere Elements.** Premiere Elements is a full-featured video-editing program that sells for under $100. Premiere Elements includes the ability to use sceneline or timeline editing. It also lets you use multiple video and audio tracks (up to 99 for each) that can make editing easier, as well as using audio from multiple sources. The program features extensive adjustment capabilities for video and audio as well as a large assortment of special effects. In addition, there is a complete titling capability that allows you to create all sorts of titles that can be placed anywhere in the video. You can export your completed movie to a wide range of preset video formats, including DVD, output to YouTube, full HD, and more. Premiere Elements is available for Mac and PCs. http://www.adobe.com/products/premiere-elements.html

■ **Apple iMovie.** iMovie is a simple video-editing program that comes free with a Mac. It has been designed with basic features to keep it simple and easy to use, but that also limits its use if you want to use effects or features more sophisticated than the iMovie can provide. For example, versions before iMovie '11 were especially limited for use with audio. The program uses a unique editing format that is sort of a hybrid between storyline and timeline editing, but does not allow you to use more than one video track and two audio tracks. iMovie '11 also includes a clever "movie trailer" feature that lets you put your clips together as if you were creating a Hollywood movie trailer. Screen your movie online at Facebook or YouTube or you can sync it to your iPad, iPhone, iPod, or Apple TV. You can also create DVDs by sending your edited video to iDVD. http://www.apple.com/ilife/imovie

■ **Adobe Premiere Pro.** Premiere Pro ($799 list price; $299 upgrade) is a full-featured professional video-editing program that uses a timeline for editing. The program is organized around panels with the specific tools needed for editing video. The timeline supports up to 99 video and 99 audio tracks for a great deal of flexibility in editing. Adobe Premiere Pro CS5.5 software is the first editing software with true native format support for dSLR HD video, which means faster editing and better playback as you work. Premiere Pro features advanced adjustment capabilities for video and audio as well as a highly controllable and very large assortment of special effects. In addition, there is a complete titling capability. You can export your completed movie to a wide range of preset video formats, including DVD, output to YouTube, full HD, and more, plus you can set up your own parameters for outputting video to nearly anything that video can play on. http://www.adobe.com/products/premiere.html

■ **Apple Final Cut Pro X.** Final Cut Pro X ($299) dramatically changed the video-editing world, though if you research it, you will discover that not everyone liked the changes. However, there is no question that Final Cut Pro X was designed to make pro-level editing easier, especially for photographers using video from dSLRs. Final Cut Pro X features advanced adjustment capabilities for video and audio as well as a large assortment of special effects. In addition, there is a complete titling capability. You can export your completed movie to screen online at Facebook or YouTube, you can sync it to your iPad, iPhone, iPod, or Apple TV, plus you can export to DVD, full HD, and more. http://www.apple.com/finalcutpro

Chapter 7

Shooting Tips

Video is all about creating movies that show off your world in color, motion, and sound. All of the ideas in this book will help you do exactly that. This chapter provides some shooting tips you can put to work immediately.

10 Key Movie Shooting Tips

1. **Remember to think shots, not shot.** You will be compiling multiple shots as you edit your video. This is quite a bit different from the single shot photographers work for in still photography. (See Figure 7.1.)

2. **Variety rules.** In still photography, you might work a single subject to get the most from it, only changing small details as you refine your composition. With video, you need big changes among your shots, because shots

Figure 7.1 A video movie is made up of multiple shots or clips.

that don't vary much from scene to scene are hard to edit into an interesting series of sequences. Look for everything from close-ups to distant shots.

3. **Honor the 10-second rule.** If you create a slide show from still images, you can leave a slide on the screen as long as you want. With video, you are limited to the length of the clip. If you don't have enough video in a clip, you will find it can be hard to edit because the "sweet spot" of a clip could be too short. Always shoot a minimum of 10 seconds of video.

4. **Audio is important and your camera mic is not the best option.** Get and use a separate microphone. An easy solution for better audio is to use a shotgun mic.

5. **Get close to your audio source.** If you need the audio from the scene, be sure your mic is close to it.

6. **Shutter speeds are different.** When you shoot still photos, you can use any shutter speed you want. You can't shoot using very slow shutter speeds with video (because shutter speeds must be faster than the typical 30 per-second frame rate, and fast shutter speeds can give your video a rough look). The optimum is around 1/30-1/90 sec.

7. **Get a neutral density filter.** Since you have less control over light coming into the camera because of shutter speed limitations, a neutral density filter can cut down bright light and give you more options for f/stop choices.

8. **Look for movement.** Video is a moving medium, so look for something moving in your shot. Even a landscape can have trees blowing, and a cityscape can have people and cars moving.

9. **Create movement deliberately.** You can add movement to a scene by panning, zooming, or moving your camera through the scene. Use this for a specific purpose related to the shot and the subject. Camera movement without a purpose can be annoying to viewers.

10. **Use a tripod when you can.** Video is always shot over time compared to the instant of still photography, so the need to keep the camera steady during the entire sequence becomes important to avoid distracting camera movement. Hand-holding a camera can be challenging, because a moving camera is not appropriate for many subjects. A tripod will give you stability and consistently better video when camera motion and the cinema verite look is not what you want.

Shooting Video for Specific Subjects

Here are some tips you can apply to shooting particular types of scenes, from sports to video portraits to zoos.

Sports

Sports is such a natural subject for video. The action of any sport is something that is implied in still photography. But with video you can experience all of the action. However, because sports are so common on television, people have certain expectations of what they will see in your video. They are not going to expect you to match ESPN in coverage of a local soccer game, but they will expect certain things, including lots of action, close-ups of that action, and shots of the players and coaches involved.

Here are some good tips that will help you think about getting better video of any sport:

- **Know your sport.** There is no question that by learning a specific sport, you will know what the key plays are and what is likely to happen. If you are not familiar with a sport, watch for a while before you start shooting. That time spent watching will help you get into the rhythm of the game and to understand at least a little of where the action is going.

- **Anticipate the action.** Anticipating the action for shooting video means more than simply knowing when action is going to occur. You need to be recording video before the action actually starts. If you wait for the action to get intense before you press the record button, you will often miss key parts of the action. (See Figure 7.2.)

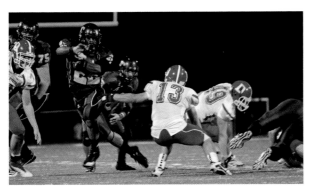

Figure 7.2

Anticipate the action as you shoot sports and always shoot more than the peak action.

- **Change your camera position.** As you watch sports on TV, notice how often the camera position changes. For TV, many cameras are used, but with most sports other than high-level college or pro games, you are able to move around the field quite a bit. Look for different angles that will show off different aspects of the game.

- **Shoot more than the game.** So often amateurs will only shoot the action of the game. Yet the game is much more than simply what is happening on the field. The fans watching the game, the coach and his or her interaction with the players, and of course the players' reactions to the game itself can all be interesting additions to your movie.

- **Don't forget the wide shot.** Remember to get that establishing shot that shows the overall field and the context of the teams, the fans, and the setting. Almost all sports fields have something about them that is unique, and finding a way to portray that in at least a shot or two will help make your video more distinctive.

People in Action

From the sports that video works so well for, to exercise, work, play, and more—all of these things can be shot with video. Usually the subject is involved in the activity and won't be distracted by the camera. This can make your subject appear more relaxed and natural. This is true whether you are working with kids or adults. And this will definitely give you more engaging movies.

The angle from which you choose to capture a certain action is extremely important and needs to be chosen carefully. Whenever any action unfolds in front of people, you will usually see those people reposition themselves to better see that action. As you start to shoot you may not be able to reposition yourself so easily, so it is important to choose a good location from the start.

Some of the ideas that you learned about shooting sports also apply to any sort of people action shots. Here are some more ideas on getting better video of people in action:

- **Demonstrate.** When you can, have somebody demonstrate or point out the basics of the action before you record it. This will help you find the best location to shoot that action, plus it will help your subject relax and become more comfortable.

- **Remember to get a range of shots.** When people are recording action, it is easy to get so focused on that action that you forget other types of shots. It is important to capture a wide shot that provides context for the action as well as detail shots that help the viewer better understand the action. (See Figure 7.3.)

Figure 7.3
One of the best
ways to capture
video of kids is to
shoot them
actively doing
something.

- **Multiple takes.** Ask your subject to repeat action so you can capture varying shots. Don't be afraid to ask for this. If you are working with someone who really enjoys what they're doing, this will be a pleasure for them. Having those different shots will really help when you are editing.

- **Shoot quickly.** When the action can't be repeated, be sure you have a zoom on your camera and shoot your variety quickly. Shoot the wide shot; then zoom in on the main action. After you capture some of the main action, zoom in on details. If you know your gear, you should be able to do this pretty quickly, so practice with your camera before you have to do shots like this.

- **Always look for cutaways.** Sometimes you just have to shoot what you can of the action, because you often can't direct what is going on when your subjects aren't actors working from a script. But you'll find you really cannot just let a sequence unfold just as you saw it when you are editing. Cutaways give you the chance to trim and edit any action effectively.

- **Look for reaction shots.** If there are other people around watching the action, try to get some shots of them reacting to the scene. This does not have to be during the peak action (you don't want to miss the action!). You can often get some great reaction shots just after action occurs.

Video Portraits

Portrait photography has long been an important part of still photography. However, a video portrait has to have more than a person's face on the screen for many minutes. A video portrait needs to include shots of your subject doing something, saying something, and engaging the viewer with some interesting ideas and action. This is certainly part of the success of Oprah Winfrey, who now does what are basically video portraits of people on the OWN Network.

One of the things that really makes a video portrait distinctive is that you can hear the person talking. You can't get that with a still photo. This adds a dimension to a person that cannot be captured in any other way. So audio becomes a very important aspect of your presentation. You need to make sure that your microphone is close to your subject and that you are recording in a quiet enough place where you will not encounter distracting sounds.

Here are some ideas to use for creating your own video portraits:

- **Get your subject to start talking.** Find a topic that your subject really cares about, then simply create a conversation around that. When people talk about something they care about, they tend to become excited and animated, which can make for good video. (See Figure 7.4.)

- **Encourage your subject to get excited and animated.** If you're asking questions, pose thought-provoking queries that will prompt the subject to talk about things they are really interested in. Don't force this, though, because that will not come across well on video.

- **Composition is critical.** You can't shoot a vertical, so you'd need to use the horizontal space of the video frame to good effect. Avoid centering. Make sure there are not distracting elements in the part of the frame away from the subject.

- **Vary your shots.** It is rare that you'll ever get video of someone speaking and then later be able to use everything they said in your finished production. You'll need to extract select phrases and then edit them so they flow together smoothly. In order to do this kind of editing, you need to have variation in your shots so that there are no annoying jump cuts. Reframe the subject to make the face larger and smaller in the composition. Then, moving from one "quote" to another will seem less jarring.

Figure 7.4
When your subject talks to you just off camera, his face is still fully visible to the camera. Simple lighting and backgrounds also can help a video portrait.

- **Look at your subject's angle of sight.** Your subject has to look somewhere as he or she speaks. A good way to handle this is to have your subject talk to you as you stand right beside your camera. This is a common technique for news interviews, so viewers are used to it. Talking into the camera is very hard to do unless you are a professional.

- **Be sure the light is flattering on your subject.** A simple and easy way of getting good light on your subject for a video portrait is to use a large light source slightly to one side of the camera or the other. The light should be spread out over a large surface, so use a diffuser or bounce the light off of a large white card.

- **Pick a good setting for your video portrait.** You can use a location that is typical of where your subject lives, works, or plays. Or you can use a simple white or black background, or an out-of-focus blurred background that clearly sets off your subject.

- **Always look for cutaways that can illustrate something about your subject.** This will help you when you edit because you can then trim a long bit of talking by cutting to another shot to cover up the edit point. Moreover, cutaways that illustrate something about the subject can also be used simply to break up always seeing the person's face.

Landscapes

Landscapes have little inherent action, yet they are one of the most common subjects for video because so many people travel to great landscape locations such as national parks. They want to record some of that beauty. Here are some tips on shooting video of the landscape:

- **A pan can be a big landscape's friend.** A pan across the landscape is a good way of showing off a big landscape without trying to get it all into one shot. Panning across the landscape provides movement that is so important to video. Practice your pans so that you know where to begin and end on the landscape and so that you pan at a speed that works for the scene.

- **Wide or establishing shots can be helpful, but don't overdo them.** Shot after shot of big scenes in video can be boring.

- **Look for the close detail.** After you have shot your wide shots and your pans across the scene, start finding details that really show off the unique qualities of your particular landscape. Close detail may simply mean showing a particular peak in a range of mountains. It could also mean focusing in on a particular part of a waterfall.

- **Watch for movement.** You usually don't want movement when you're shooting still photos of a landscape unless you're trying to blur water in a stream. Yet even a little bit of movement, nearby leaves blowing in the wind, trees moving, birds flying in the air, clouds blowing, can give more life to video.

- **Consider a tilt.** Most the time, photographers only think about panning across a landscape. Yet if you are on a high vantage point or you have some very interesting sky, smoothly tilting your camera up or down through the landscape can also be quite interesting. (See Figure 7.5.)

- **Don't rush your shots.** Landscapes can take some time for a viewer to absorb visually, because there are so many things to look at, and so many potential points of interest. In addition, viewers have an expectation for landscapes as being peaceful. You can always edit longer shots to short clips if you want to create a more energetic look at a landscape.

Figure 7.5
Tilting up through a landscape into the sky or vice versa can be an effective way of incorporating movement into a landscape video.

Flowers

Flowers are another very popular subject for photographers and videographers. Flowers have such an inherent liveliness in color and form, plus they move a lot in the wind, so they make attractive subjects for both photography and video. There usually isn't much sound associated with flowers other than wind so often flower videos are set to music.

Here are some tips on getting the best flower shots:

■ **Watch your background.** Since you have the limitation of slow shutter speeds for video, you will often end up with a small f/stop that will make your background more distinct and even distracting. Be aware of what is happening in your background and position your camera accordingly.

■ **A pretty flower is not automatically a pretty video subject.** Look at your LCD to be sure that the flower is being portrayed well. For example, make sure that the video is not overreacting to harsh light.

■ **Use a telephoto focal length for softer backgrounds.** The telephoto will change the perspective of the scene and produce less depth-of-field so that many backgrounds can be changed from distracting to gentle and complementing for your flower. If your lens won't focus close enough, get extension tubes to allow you to focus closer. (See Figure 7.6.)

■ **Shoot through out-of-focus foreground flowers to a sharp flower behind them.** This can produce a very distinct look as the flowers move in the breeze.

■ **Use a wide-angle focal length to show off the setting.** Get in close with your wide-angle lens—so close that the flower dominates the scene and the rest of the setting becomes small and background. A wide-angle lens at a distance from a flower is usually not very effective.

■ **Use the movement of the flower.** The challenge is getting the right movement. If the wind is too strong, the flowers will blow around so much that they won't be very clear in the video. Be patient and wait for the wind to change and you will almost always find at least a few seconds of appropriate movement.

■ **Create movement of the flowers.** If there is no wind, don't be afraid to add a little of your own by blowing on the flowers.

Figure 7.6
Get in close with a wide-angle lens to show a flower in its environment.

Wildlife

Wildlife is a very attractive subject for video. Many people want to try shooting wildlife with video because they see so much of this on television. Wildlife is definitely a challenge to shoot for video because you often need quite a lot of video to edit down to something that looks interesting. You only need one photo for photography, but you need a group of shots for video, yet getting a lot of video of wary animals can be difficult.

You will need a long telephoto focal length. This can be a zoom or a single focal length lens. You're going to find it difficult to shoot much wildlife with less than 300mm of focal length. More is better. Modern teleconverters are very valuable when used with a good lens to start with. They magnify what is seen through that lens and can be a less expensive and more portable way of getting more focal length. The downside is that they reduce the light coming to your sensor.

Telephotos are extremely difficult to hand-hold when shooting video. You're going to need some sort of support. A tripod is best even though it can be awkward to move with. A monopod can help, but it can also be challenging to use with a long telephoto lens.

Consider these tips when recording wildlife:

- **Go to places where animals are habituated to people.** Wild animals can be very difficult to approach if they are not used to people. Yet there are many locations in protected parks and nature center areas all around the country where wild animals have become acclimated to the presence of people. They tolerate people getting close enough to get good images.

- **Get a field guide.** The more you understand about the subject that you are trying to record, the easier it will be for you to get close to it. Going to a wildlife refuge and simply hoping to get pictures of the birds there can be an exercise in futility if you don't understand a little bit about their habits and habitat.

- **Carefully move closer.** Wild animals are ever on the alert for danger. If they think that you might be dangerous, they are not going to let you get close. Move slowly with no sudden movements. Do not stare at the animal as you start to move closer. Move in a zigzag, "casual" manner. Stay downwind of mammals and avoid walking over a rise that will put your silhouette against the sky. (See Figure 7.7.)

- **Watch for a change in behavior.** As you move closer to your subject, watch the behavior of the animal. That will give you clues as to what they are going to do next. If you find that the animal suddenly starts making a

Figure 7.7
If you learn a bit about your wild-life subjects, you will be better able to find them and get close.

lot of noise or starts moving around in a different pattern, stop. Let the animal relax a bit before you try to move closer.

- **Respect your subjects.** As you get closer to an animal, you may find it gets agitated and upset. Stop. Respect the subject and back off. Also be very wary of getting too close to animals that are with their young because that can be dangerous for everyone.

- **Get the establishing shots.** Don't forget to get the wider shots of the location before you move closer to the animal. These shots can be very important when you are editing.

- **Keep shooting!** As you're moving closer to the animal, keep shooting all the way. You'll be surprised at how many of these shots you will be able to use when editing and how frustrated you will be if you don't have those shots.

- **Use a blind.** In many situations, wildlife video is really only possible when you use a blind, a kind of camouflaged hiding place where you can conceal yourself while shooting. You can use the same type of blinds that game hunters put to work, even if your "shooting" is of the non-lethal variety.

Zoos and Aquariums

Zoos and aquariums are great places to take interesting video of animals, and people, too! As with recording animals in the wild, you are going to need a telephoto focal length. Zoo animals and certain large exhibit aquarium animals may be easy to see as you walk through the area, but they may be difficult to record on video without that telephoto. The telephoto helps bring in views of animals at the far parts of enclosures, plus you can isolate the animal in the shot and even rid the shot of fences and other enclosures.

A wide-angle lens can help at an aquarium so that you can get closer to the glass. That will minimize reflections too.

Zoos and aquariums today are very interesting places, so don't only shoot the animals. Record some of the setting because that will really help make your video more engaging. In addition, be sure to shoot the people at the zoo, especially reactions of people as they see the animals. (See Figure 7.8.) All of these things will give a richer look to your video and make it easier to edit.

Figure 7.8
Include people in your shots to show the interaction of people with the animals.

Here are some additional specific tips for getting better video at the zoo:

- **Bring a tripod if you can.** Animals are not always doing interesting things. So it can help to set up your camera and telephoto and just wait until something more interesting happens. Not all zoos will allow a tripod, so you may have to bring in a monopod or look for other ways to support your camera.

- **Use a beanbag.** If you can't use a tripod or don't want to carry one at the zoo, bring along a beanbag. You almost always will have places to put the beanbag to help support your camera and lens. That could be anything from a rock wall to a bench or a signpost. This will help steady your shot and make the resulting video easier to watch.

- **Get to the zoo early.** You will find it a lot easier to get great shots at the zoo if you are there when it opens to avoid the heavy crowds. That makes your shooting easier because you don't have to jostle for position. In addition, animals are often more active early in the morning.

- **Find out feeding times.** Zoos typically have very specific times that they feed the animals. The animals know this, just like the dog that knows when it is dinner time. Animals often become more active at this time and start moving around more. This would be a great time to capture movement for your video.

■ **Look for special photo opportunities and events.** Many zoos will offer unique tours and times for photographers. Check to see if the zoo opens earlier for photographers for a price. Also check to see if there are tours that take you into places that the general zoo attendee isn't allowed to go.

Travel

Traveling is a great way to find interesting and unique subject matter for photography. It is also an excellent way of capturing unique video for your movies.

Some of the tips that were provided for the landscape section of this chapter also apply to travel photography. But travel photography is much more than big landscapes, cityscapes, or monuments. Consider these tips when you are shooting video while traveling:

■ **Immediately get that establishing shot.** So much of travel videography is dependent on context. A viewer needs to have that context in order to understand what is going on. Simply thinking you will fix that with narration later doesn't help the viewer. They want to see the setting of your travel location. Before shooting that close-up of some detail of a magnificent cathedral, capture a sequence showing the edifice in its surroundings, amidst the adjacent structures.

■ **Shoot the details.** The viewer wants to actually see those details so make sure you get in close and capture those details on video. When you've established where you are, move in close to show interesting parts of your cathedral, such as mighty doors, ornate windows, or intricately carved statues.

■ **Find unique signs.** When you are traveling, you will often find very interesting and unusual signs that are unique to the location. These can be great to capture as part of your movie.

■ **Show your active family.** When on vacation with your family, don't just record your family waving at the camera; capture shots of your family running through the waves in the ocean or investigating a shell on the beach.

■ **Record all sorts of people.** As you travel, you will find interesting people who are an important part of the location—maybe a street musician or a local merchant. Capture them with video. Find people who are active in this setting—they tend to be the easiest ones to record on video. (See Figure 7.9.)

Figure 7.9
People can add color and interest to your travel movie, as well as immediately tell the viewer this is a special place.

- **Add movement to architecture.** Historic buildings, for example, are a very important part of travel video. But simply pointing a camera at a building can be rather dull. Look for elements of the building that you can pan across or that you can tilt up and down. A dramatic and very interesting way of capturing architecture is to get close with a wide-angle lens and then tilt from the bottom of the building up to the top.

- **Find out if there are unique events happening.** At many travel locations, there will be special events that can be ideal for video. When people are involved in big events, whether that is a parade or a festival, you can often record them without anybody being worried about what you are doing.

Events

Events from birthdays to weddings are ideal for video. They include lots of action, often with great color, plus there are usually wonderful sound opportunities. A challenge with any event is that there sometimes is so much going on that it is hard to know exactly what to record. Review the ideas from Chapter 4 to find a focus for your movie.

Here are some other things that can help you create a movie about an event:

- **Look for the core visual aspect of the event.** Some events are based on something specific such as a parade or a person (or persons) doing something, so this is easier to find. Other events have a theme but don't have any one specific thing going on, such as a festival. In that case, think a bit about what the festival is truly about and then look for visuals that reflect that.

- **Shooting angles are critical.** You need to move around and find an angle that will help you visually capture what is truly important about a particular scene. So, for example, if you are recording artists drawing in chalk on pavement, you need to find a position that is going to show off both the artists and their work. (See Figure 7.10.)

Figure 7.10
Getting the right angle for an event is a key part of shooting video for it. This will help you best show what the event is all about.

- **Be prepared.** Events can be very hectic. Have your gear set up and ready to go (batteries charged, extra memory cards available) before the festivities begin.
- **Coverage is vital.** Be prepared to shoot quickly and constantly when you are covering an event. Events generally are not going to stop while you think about what to do next. Keep shooting, but think about capturing variety and finding the essence of the event.
- **Pay attention to audio.** Sound can be tricky at any event because there are so many things going on and because you can't always get up close to the important sound. A shotgun mic doesn't do a great job when you are at some distance from the source of the sound. In situations like this, you may have to do some unique things to record the sound, including placing wireless microphones right up by the source of the sound or by using a separate recorder to get in close to the sound source.

Concerts and Plays

Both concerts and plays have two distinct parts to consider: the stage where the performance is happening, and the audience. Plays, and sometimes concerts, have a distinct beginning, middle, and end.

You will be able to record the essence of a concert or play with your dSLR. However, at this state of technology, you will not be able to record such an event from beginning to end. Sometimes they don't even let you record for more than about 10 to 15 minutes. If you need to continuously record a concert or play, then you need to use a standard camcorder.

However, the dSLR gives you some unique opportunities for capturing an impression of a play or concert. A dSLR gives you the chance to change lenses for effect as well as adjust your ISO setting when the light changes. A camcorder won't provide the same opportunities. In addition, a dSLR will let you shoot with shallow depth-of-field which can be very helpful in isolating certain parts of a performance.

Some of the tips offered for events also apply to concerts and plays. Here are some other things to think about:

- **Get the wide shot.** It's important to capture an overall shot of the venue of the concert or play. This is one thing that dSLRs do really well because they allow you to use a wide-angle lens.

- **Be sure you get the details.** Put on that telephoto lens and get in tight on details of the performance. Focus in on specific musicians in the band. Focus in on specific actors as they perform the play.

- **Use a zoom to quickly change from wide to close shots as you shoot.** A quick zoom can be really helpful to give you distant and close-up views so you edit from a wide shot to a more intimate shot as you assemble your movie. The entire zoom shot from wide to close might be awkward to include, so this is where having available cutaways will help. You can cut from the wide shot to the close shot and skip the intervening zoom motion if you need to.

- **Include the audience in some of your shots.** Shoot the audience as the performance goes on. Such shots help you edit the actual performance, especially when you have made a quick change from a wide to a close shot, and give context for the performance.

- **Think ahead for recording sound from a play.** If the actors have microphones and are using a sound system, you may be able to place a microphone near one of the speakers. You might also be able to use a separate recorder to record the performance directly from the soundboard. If you are close enough to the performance, a shotgun mic might be enough. Or you can use a wireless mic that you have put somewhere on the stage.

■ **Think ahead for recording music.** Music can be very tricky to record and pros often use multiple mics carefully placed in order to do this. You probably won't be doing that. But realize that if you are shooting from one side of an orchestra or the other, for example, you may get an over emphasis of certain instruments if your only mic is the one that is on your camera. If the performance is being mic'd for a sound system, you can often put a microphone by one of the speakers. Another option is to place a wireless microphone somewhere near the center of the stage so that it picks up the instruments fairly equally. (See Figure 7.11.)

Figure 7.11
Recording music at a kids' concert can be challenging. Try to find a position midway to the group and at a moderate distance.

Index